IMAGES
of America

GREENWICH
VILLAGE

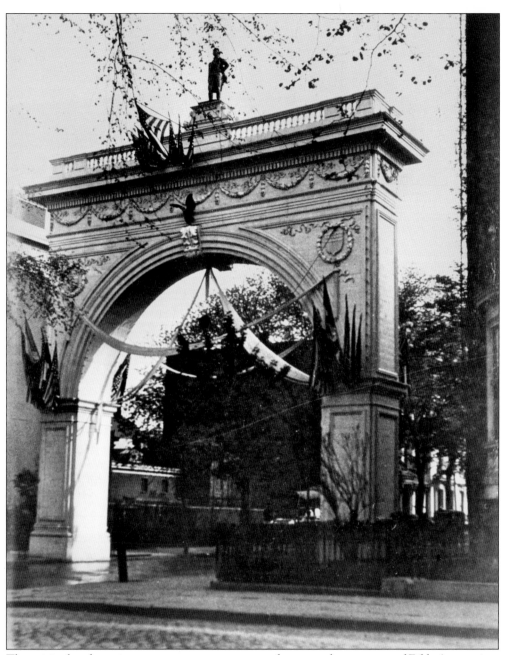

The original arch, a temporary structure, was erected to span the entrance of Fifth Avenue just north of Washington Square in April 1889. It was one of three triumphal arches through which military and civic parades marched during the three-day centennial celebration of Washington's inauguration as president of the United States. (Courtesy New-York Historical Society.)

ON THE COVER: Washington Square Park is decked out for Mayor John F. Hylan's lawn party. Nicknamed "Red Mike," New York City's mayor (1918–1925) ran for office on the Tammany Hall ticket in 1917. He began his career as motorman on an elevated train. (Courtesy Greenwich Village Society for Historic Preservation.)

IMAGES
of America

GREENWICH
VILLAGE

Anita Dickhuth

ARCADIA
PUBLISHING

Published by Arcadia Publishing
Charleston, South Carolina

Printed in the United States of America

Library of Congress Control Number: 2009936802

For all general information, please contact Arcadia Publishing:
Telephone 843-853-2070
Fax 843-853-0044
E-mail sales@arcadiapublishing.com
For customer service and orders:
Toll-Free 1-888-313-2665

Visit us on the Internet at www.arcadiapublishing.com

CONTENTS

ACKNOWLEDGMENTS

Many thanks for patience and guidance go to Sheryl Woodruff at the Greenwich Village Society for Historic Preservation. The author would also like to thank the staff at the New-York Historical Society for their knowledge and generous help. Many thanks are extended also to Village historian and zoning expert Doris Diether for her knowledge, availability, and generosity in organizing and creating the chapter on the houses of the Village. It would have been impossible to write this volume without her. I also want to thank my family for their patience, understanding, and support during this undertaking. Thanks also go to Tatiana Toro for her scanning and organizing expertise and to Evonna Gaines. I would also like to thank Damon Campagna at the New York City Fire Museum on Spring Street for sharing his research materials and knowledge. Thanks also go to my acquisitions editor, Erin Vosgien, for her support and guidance. My thanks go to Nuri Akgul, Lisa K. Brugman, Phill Niblock, Jean-Claude van Itallie, and Kore and Marianne Yoors for allowing me to use their photographs and programs, and to Richard Blodgett, Marilyn Dorato, and the Museum of the City of New York.

Unless otherwise noted, images are from the collection of the author.

INTRODUCTION

From virgin forest to farmland to spacious estates to Federal houses, Greek revival homes, tenements, apartment buildings, and impressive university buildings, Greenwich Village continues to reflect its rich history on every corner. Every building has its own story, often involving a notable person or incident. Many historic events—too many to list in detail—have taken place within its boundaries. Prominent people of all professions reside here. Greenwich Village is a destination for anyone and everyone. It is a culinary, entertainment, and historical destination. Schools and universities and publishing companies are situated here. But what stand out are the people who have protected the Village from those who would try to make it ordinary, and override its uniqueness in the name of progress.

One of the first confrontations began in 1808 when the city needed a plan to extend its border northward. While living at the corner of Christopher and Bleecker Streets, chief engineer John Randel Jr. was given the task to create a plan. His proposal called for evenly spaced numbered streets running from the East River to the Hudson River beginning with First Street. The city's common council adopted Randel's grid plan. However, villagers protested vociferously and steadfastly for over a year. Meanwhile a 62-page pamphlet entitled *A Plain Statement, Addressed to the Proprietors of Real Estate in the City and County of New York by a Landholder* was published anonymously. In it, Randel's plan was called "a more needless and ill-judged attack on private property." As a result, the proposed grid was revised. The original would have required the entire West Village to have been demolished and rebuilt. The author of the pamphlet was Clement Clark Moore, the village church warden who later wrote "A Visit from St. Nicholas."

A century later, a battle over the future of the village was fought when Seventh Avenue was extended to Varick Street and the Seventh Avenue subway installed. Villagers turned this disruption to their advantage by winning restrictions on development as part of the first zoning ordinance in any American city in 1916. It created eight separate residential districts within the Village.

Another major battle against the incursion of modernity took place in 1937 when the trustees of Snug Harbor, who were guarding the business affairs of 800 sailors at Snug Harbor on Staten Island, resisted the efforts of developers and real estate agents who saw in the fine location of Washington Square north, east of Fifth Avenue, a site for an apartment development that would be the finest in the city. Thankfully, the seven trustees issued a statement which said, "The trustees feel that to lease 'the row' for modern apartment buildings would be to break faith with the original owners, and so those old buildings, physical reminders of a period when New York was not the largest city in the country will go on serving as relics of a glorious past."

Another proposal in the 1960s challenged the zoning laws for the first time since 1916. This time, a nonpolitical community group called Save the Village was organized by someone who got involved because his landlord wanted to tear down his house before the zoning laws took effect. Architects and city planners had rezoned the whole city and had come up with zones in chunks of 30 and 40 blocks instead of observing that this formula could not be applied to the Village. In

charge were Stanley Tankel, of the Regional Plan Association; Robert Weinberg, zoning chair of Community Board 2; Arthur Holden, of the City Planning Commission; and Robert Jacobs, architect. Through their efforts, Save the Village won the fight for an appropriate zoning pattern for the Village. Save the Village cleverly enlisted its team of lawyers from each the political parties: Bill Passanante from Tamawa Club, the Democratic club in the lower West Village headed by Carmine DeSapio. (DeSapio was the last head of the Tammany Hall political machine to be able to dominate municipal politics); Ed Koch (who later became mayor of New York City) and his legal partner, Gwen Worth, from Village Independent Democrats (VID); MacNeil Mitchell from the Republican Club; and Leon Braun from the Liberal Party Club. A handful of women—Doris Diether, Jane Jacobs (Robert Jacobs's wife and author of *The Death and Life of Great American Cities*, a definitive work on urban planning), Ruth Wittenberg, Verna Small, Shirley Hayes, and Margot Gayle—were engaged as activists.

Community activist Doris Diether continues her role today as the longest-serving member of a community board in New York City. One example of her crusading spirit: in the 1960s, the North Village and South Village were totally separate entities, politically and ethnically. Carmine DeSapio's Tamawa Club controlled the South Village. Save the Village discovered that the landlord was going to evict a group of Italian tenants living at 40–42 MacDougal Street. So Doris got involved on behalf of the tenants there. She met with the ladies in their kitchens to discuss their problems. Doris inspected all the apartments and made a list of all violations in the structure and sent it to the New York City Department of Buildings. A week later, the building inspector's report came back with only one of the many violations they had complained about. So, Doris looked in the phone book and found out that the buildings commissioner lived in the Village. She called him at home at night; he was in the middle of a dinner party. She explained to him what had happened. He told Doris to send the list of violations directly to him. The inspector was sent out again, and this time he came back with a long list of violations for the landlord to fix, and the case went to court. Ed Koch volunteered to be their lawyer for free. The tenants were not evicted.

Before the court case, Doris and six of the Italian women entered Carmine DeSapio's men's club on MacDougal Street. Men tried to block their entrance, but they went in and confronted DeSapio. She said to him, "What are you doing for your constituents who are having trouble with their landlord?" He said, "I have a lawyer from my club who works on these things." Doris, even though she was not a lawyer, said, "I know, I get all the cases he louses up." She went to court to aid Ed Koch. He would defer to her knowledge of the circumstances in the court case. Confronting DeSapio "made quite a fuss," Diether says. After that incident, the ladies began to realize their elected representatives were not really looking out for them.

Diether was the only female to attend a one-time course in zoning given by the City Planning Commission in 1960. She later taught a course in zoning laws at the City University of New York and the Municipal Arts Society. Diether consistently impresses with her determination and clarity of vision. She started her civic career in 1959 fighting to keep free Shakespeare in the Park against Robert Moses, the notorious city planning commissioner. He also had a plan (which was thwarted) to extend Fifth Avenue through Washington Square Park as Fifth Avenue South and line it with new high rise buildings and turn Broome Street into a super highway going east-west across Manhattan Island.

Doris Diether (pictured in chapter six) is proof that one person can change the world. She became an expert in zoning issues. Her work helped stabilize the charm and quirkiness of the Village by fighting vigorously for the landmarking of many older buildings. The houses in chapter two are based on photographs taken by Doris in the 1960s to set up the Greenwich Village Historic District. Historic District Council, Greenwich Village Society for Historic Preservation, and other organizations continue to be concerned about this area.

One

EARLY HISTORY

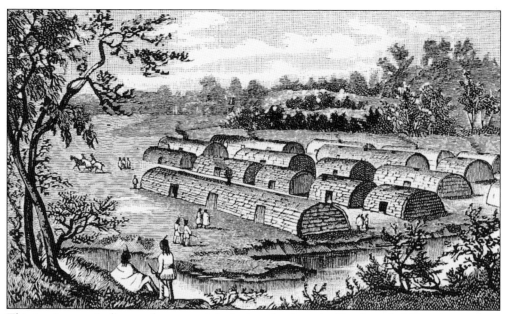

This is a Lenape Indian settlement as it looked at the time the Dutch settled New Amsterdam. The Lenape Indians called the island Mannahatta (island of the many hills). It is believed one group had an encampment near where Christopher Street now meets the Hudson River.

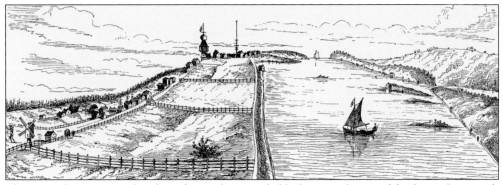

This view of New Amsterdam from the north was probably drawn at the site of the future Greenwich Village at a time when farms, plantations, and *bouweries*, as the Dutch settlers called their farms, were all there was in the area. This is an engraving based on an earlier pen-and-ink drawing.

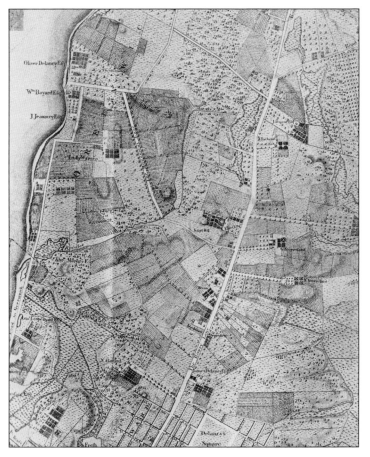

This map of Greenwich Village was drawn in the 1760s by Bernard Ratzer for English governor Sir Henry Moore. The village shown here is a patchwork of Dutch farms, or *bouweries*, forest, sandhills and marsh, and streams. The Bowry Lane runs down the middle of the map to the right, and the Road to Greenwich goes up the left side of the island. The map shows property owned by prominent landholders.

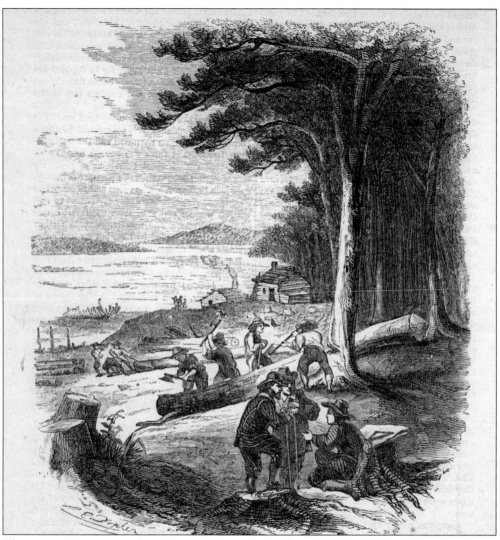

This engraving appeared in *Harper's Magazine* in the mid-1800s with the caption "Early commercialization of New York City in the 1600s." (Courtesy New York Public Library Picture Collection.)

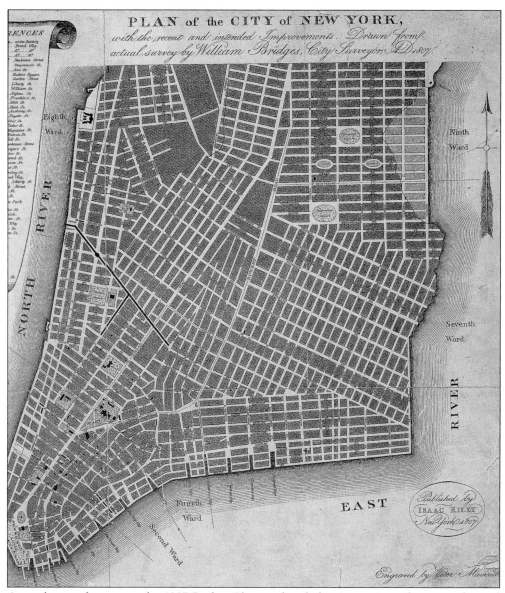

An early map documents the 1807 Bridges Plan, and includes Aaron Burr's house, Richmond Hill, three blocks above the canal and the New York State Prison in the upper left-hand corner. The Hudson was called the North River. The dark line at left center is the canal, later Canal Street. The Road to Greenwich runs up the left side of the island. (Courtesy New York Public Library Picture Collection.)

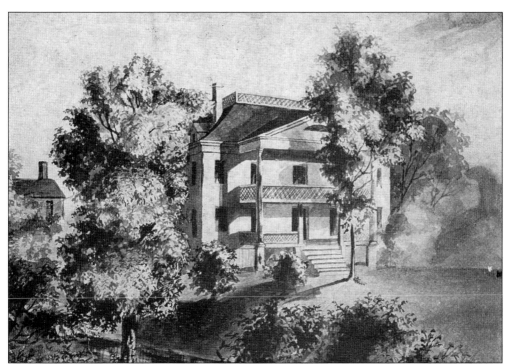

Richmond Hill, situated until 1849 near what is now Varick and Charlton Streets, was once a palatial mansion that served as George Washington's headquarters. Later, it was the country home of Aaron Burr and his daughter, Theodosia. Burr was vice president under Pres. Thomas Jefferson. (Courtesy New York Public Library Picture Collection.)

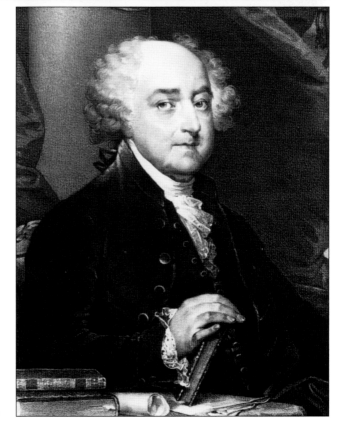

Richmond Hill was the official residence of Vice Pres. John Adams and his wife, Abigail, during the short period of the first administration when the national capital was New York. Abigail wrote, "In natural beauty it might vie with the most delicious spot I ever saw." (Courtesy Library of Congress.)

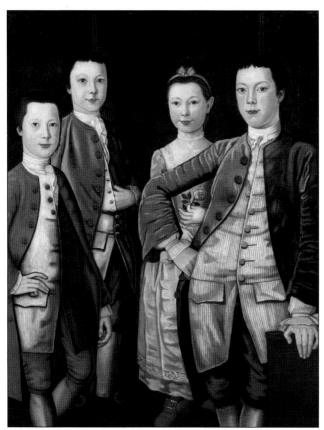

The first European-born Manhattanite was Sarah Rapalje, who, in 1639, married the overseer of a tobacco plantation in what would later become Greenwich Village. A century later, Rapalje descendants posed for this notable primitive painting. Shown in John Durand's 1768 oil painting *The Rapalje Children* are, from left to right, Garret (b. 1757), George (b. 1759), Anne (b. 1762), and Jacques (b. 1752). (Courtesy New-York Historical Society.)

This plan of the city of New York, from the original copy published in 1789, shows the road to Boston, also known as Bowery Lane. In the upper left-hand corner is the road to Greenwich. (Courtesy New York Public Library Picture Collection.)

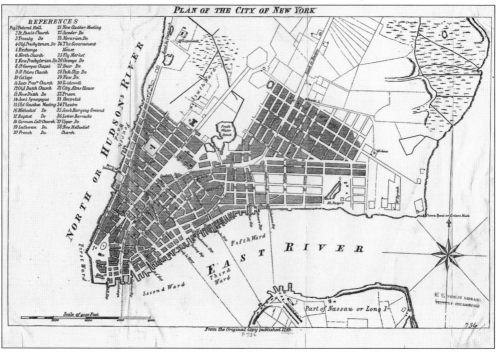

PLAN OF THE CITY OF NEW YORK

REFERENCES

1 Federal Hall.
2 St. Pauls Church.
3 Trinity Do.
4 Old Presbyterian Do.
5 Exchange
6 North Church.
7 New Presbyterian Do.
8 St. Georges Chapel.
9 St. Peters Church.
10 College
11 Scots Pres.n Church.
12 Old Dutch Church.
13 New Dutch Do.
14 Jew's Synagogue.
15 Old Quaker Meeting
16 Methodist Do.
17 Baptist Do.
18 German Calt Church.
19 Lutheran Do.
20 French Do.
21 New Quaker Meeting
22 Seceder Do.
23 Moravian Do.
24 The Government House
25 Fly Market
26 Oswego Do.
27 Bear Do.
28 Peck Slip Do.
29 New Do.
30 Bridewell.
31 City Alms House
32 Prison
33 Hospital
34 Theatre
35 Jew's Burying Ground
36 Lower Barracks
37 Upper Do.
38 New Methodist Church

NORTH OR HUDSON'S RIVER

EAST RIVER

First Ward
Second Ward
Third Ward
Fifth Ward

Part of Nassau or Long I.

Scale of 4000 Feet.

From the Original Copy published 1789.

14

COMMON SENSE;

ADDRESSED TO THE

INHABITANTS

OF

AMERICA,

On the following interesting

SUBJECTS.

I. Of the Origin and Design of Government in general, with concise Remarks on the English Constitution.

II. Of Monarchy and Hereditary Succession.

III. Thoughts on the present State of American Affairs.

IV. Of the present Ability of America, with some miscellaneous Reflections.

Man knows no Master save creating HEAVEN,
Or those whom choice and common good ordain.

THOMSON.

PHILADELPHIA;

Printed, and Sold, by R. BELL, in Third-Street.

MDCCLXXVI.

Common Sense, which was published anonymously by Thomas Paine in 1776, became an instant best seller. It challenged the heretofore accepted authority of royalty and helped ignite the American Revolution. Paine's last years were spent in poverty in rooms on what are now Bleecker and Grove Streets.

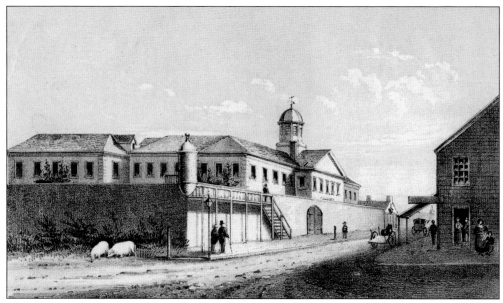

This 1814 southeast view of the New York State Prison looks north on Washington Street from Christopher Street towards Perry Street. The first prisoners were received in November 1797. The total building cost was $208,846. Before proper sanitation efforts were in place, pigs roamed free to clear the streets of garbage, as seen in the lower right-hand corner here. (Courtesy New-York Historical Society.)

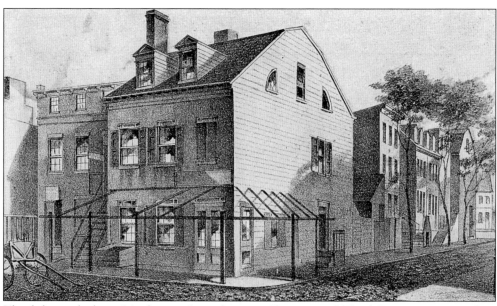

This lithograph shows Manhattan Street between Houston and Third Streets at a time when wooden houses dominated the scene. After the great fire, which demolished acres of wooden buildings in lower Manhattan, the laws were changed, mandating that houses be built of less combustible material. (Courtesy Pageant Print Shop.)

Two

HOUSES

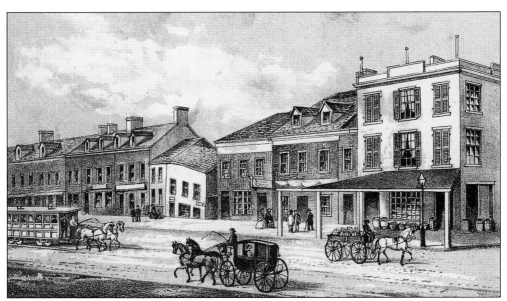

This view is of Fourth Avenue between Tenth and Eleventh Streets in 1861. (Courtesy New York Public Library Picture Collection.)

Pictured are Nos. 25 and 27 Charlton Street. In 1918 and 1919, they were home to Edna St. Vincent Millay. The two houses are on the same plot and share an inner courtyard. The entrance on the right once led to a stable in the back.

The house at No. 32 King Street, with charming posts and cornices over the top-floor windows, also lays claim to a colorful event. On July 4, 1855, the owner of 19 Charlton Street fired a gun into the air and inadvertently shot a neighbor, Mrs. Samuel Phillips of 32 King Street, who was celebrating on her back porch. The episode was considered an accident, and Phillips survived.

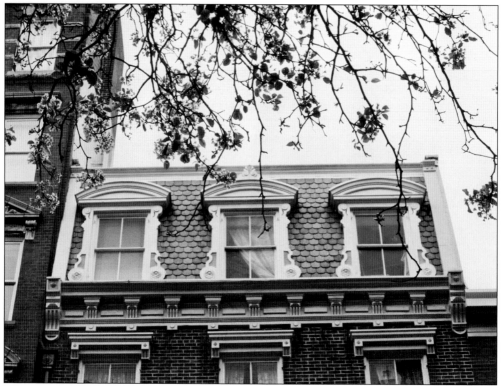

In the 19th century, much of lower Manhattan was filled with Federal-style homes. Back then, the block was just another residential street. Author James Fenimore Cooper even sneered that the homes on Charlton, King, and Vandam Streets were "second-rate genteel houses" in comparison to the then-majestic residences near the intersection of Bleecker and Thompson Streets, where he lived briefly in 1833.

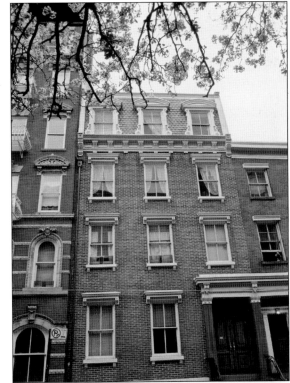

During the second half of the 19th century and into the opening years of the 20th century, most homes on Charlton Street were coal-heated. This coal chute cover in front of 19 Charlton Street, from around 1845 to 1850, is a rare relic of that era. It was made by Cornell's Iron Works, one of New York's best-known foundries of the period.

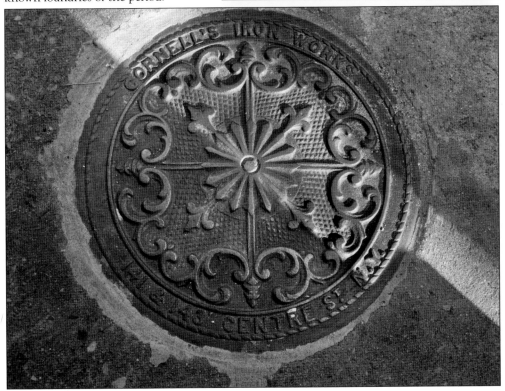

This view is of the corner of Houston and Cannon Streets. (Courtesy New York Public Library Picture Collection.)

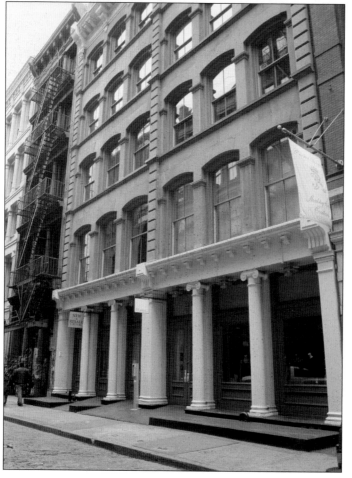

No. 113–115 Mercer Street lies in the Soho Cast Iron Historic District between Prince and Houston Streets. This impressive store and warehouse was designed by Julius Borkell and built in Italianate style. It was constructed in 1872.

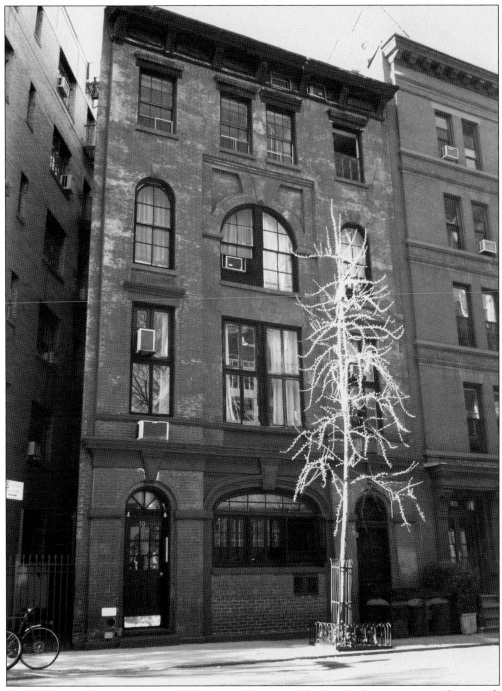

No. 70 Barrow Street was originally designated as one of the first firehouses to serve Greenwich Village. It was erected as a three-story structure in 1852. The fourth floor was added in 1880, when the building was renovated into an apartment house.

is the one-room and appurtenances apartment characteristic of San Francisco and London. Utmost utility of space is represented and such installations as a mediaeval peasant type bed, a desk and desk window, bench radiators, cedar closets, etc., are features specially designed to the needs of the busy worker and to harmonize with this unique type of building.

"TWIN PEAKS," 102 BEDFORD STREET,
NEW YORK
Designed by Clifford R. Daily

An Apartment House in Greenwich Village
In designing "Twin Peaks" an effort has been made to provide housing suitable for the "cultural worker." The general scheme

Apartment in Attic

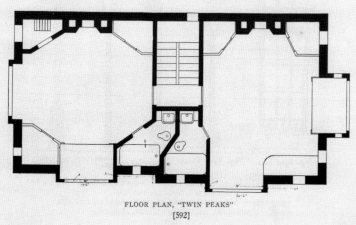

FLOOR PLAN, "TWIN PEAKS"
[592]

These pages from *Architectural Record* magazine show the exterior of Twin Peaks and its floor plan. The architect, a struggling newcomer, was given financing to build his dream house. As it neared completion, the financier became disillusioned and banished the architect from the house, giving him a small yearly stipend. (Reprinted with permission from *Architectural Record*, copyright 1926, The McGraw-Hill Companies, www.architecturalrecord.com.)

22

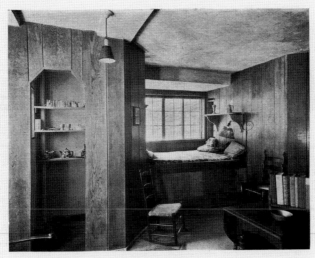

First Floor Apartment

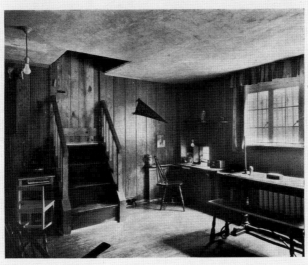

Apartment in Basement
"TWIN PEAKS," AN APARTMENT HOUSE AT 102 BEDFORD STREET, NEW YORK
[593]

This Twin Peaks advertisement from *Architectural Record* magazine shows the first-floor apartment and the basement apartment. (Reprinted with permission from *Architectural Record*, copyright 1926, The McGraw-Hill Companies, www.architecturalrecord.com.)

This tile, a relic from the past, is on the former Blue Mill restaurant building at 50 Commerce Street. It was also known as the Grange Hall, a favorite eating place that occupied this 1912 structure for more than 50 years. Photographer Berenice Abbott had a studio at this address.

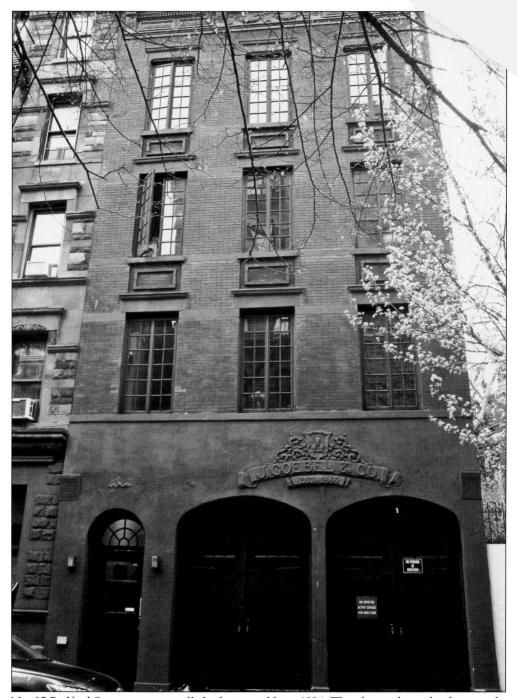

No. 95 Bedford Street was originally built as a stable in 1894. The plaque above the doors reads, "J. Goebel & Co., Est. 1865." It is a four-story structure sporting a Queen Anne–style pediment. It was converted into apartments in 1927.

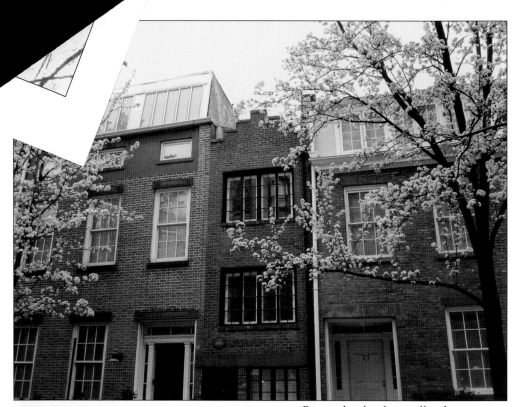

Reputed to be the smallest house in Greenwich Village, No. 75 1/2 Bedford Street, a 9.5-foot-wide home, was constructed in 1873. The most notable resident was Edna St. Vincent Millay, the Pulitzer Prize–winning poet of 1923. Millay and her Dutch husband, Eugen Jan Boissevain, renovated the home from the Italianate to the Dutch Colonial style in the 1920s, when they added the Dutch stepped gable.

Abutting the narrowest house on Bedford Street is the oldest extant house in Greenwich Village, the Isaacs-Hendricks House (1799–1800). The originally freestanding clapboard siding fronts Commerce Street, shown here, and the 1836 brick front is seen on Bedford Street. Hendricks and his father-in-law, Isaacs, were New York agents for Paul Revere's copper-rolling industry.

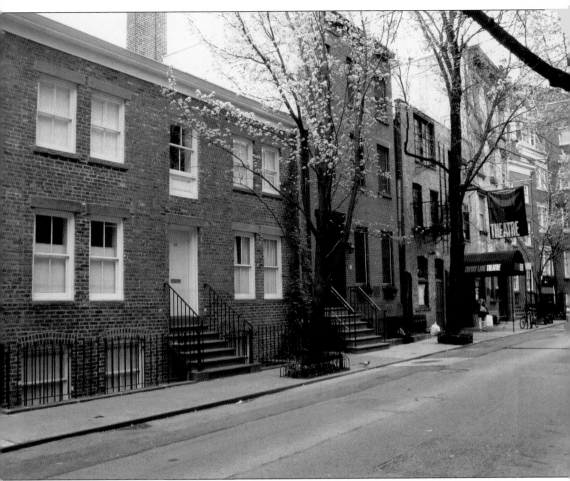

Going west on Commerce Street from the Isaacs-Hendricks House, and around the corner from Edna St. Vincent Millay's home on Bedford Street, are homes built in the 1840s. The houses shared a common backyard with no fence, making it easy to access the Cherry Lane Theatre seen on the right. Millay and her colleagues who founded the theater lived in these houses. According to one source, the theater got its name when an actor replied to a tourist who had searched for a name akin to the Drury Lane Theatre in London. Rather than using "Cheery Lane" (as opposed to what sounded like "dreary"), he replied "Cherry Lane." (The London theater was actually named for Sir William Drury's home, which stood on the street.) Another story claims that Commerce Street was once called Cherry Lane.

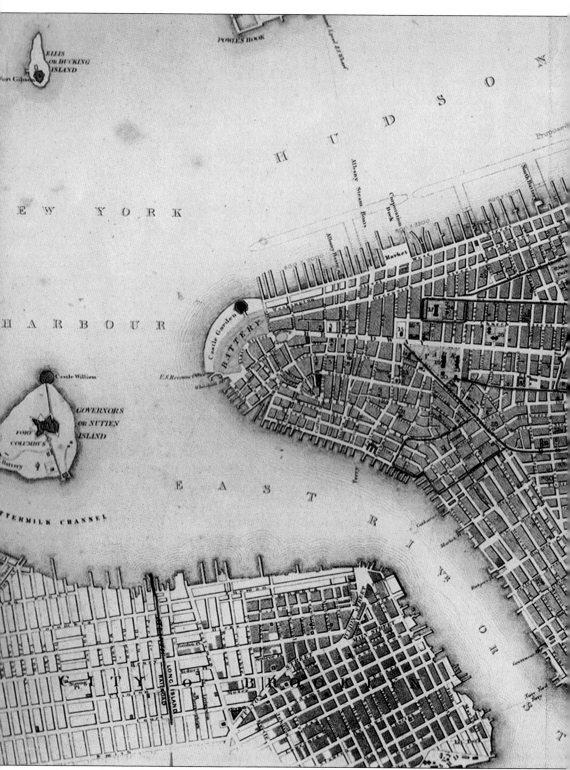

An 1840 map shows the grid pattern above Fourteenth Street and the avenues before they were

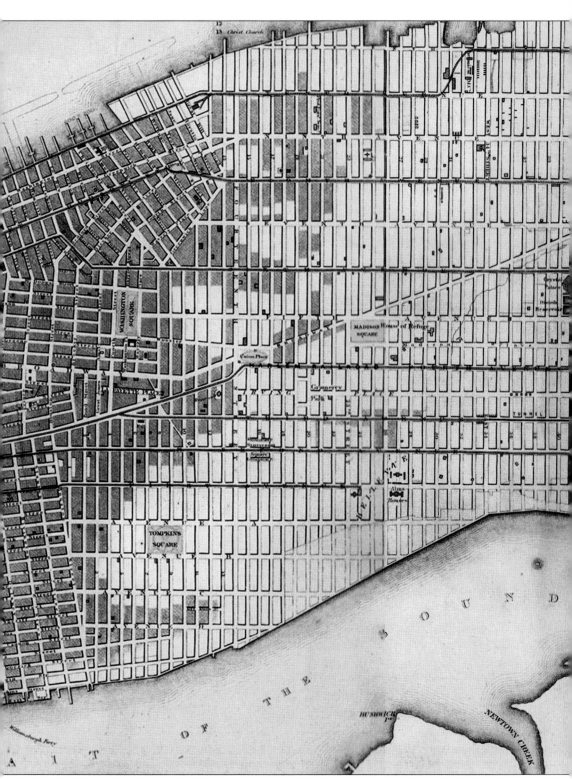

straightened and extended northward. (Courtesy New York Public Library Picture Collection.)

No. 39 Commerce Street was built in 1831–1832 in the late Federal style. It and its twin, No. 41, were changed to the French Second Empire style when the mansard roofs were added in the early 1870s.

No. 114 Waverly Place was altered in 1920 into a Spanish- or Italianate-style house. In another change in 1920 by William Sanger, a large arched studio window was added. The entrance was redone in Italian styling, with a stoop and round-arched doorway and windows. Sanger's wife, Margaret Sanger, founded the first birth control clinic and spread her ideas with her *Family Limitation* pamphlet. This was the home of painter Jacob Gitlar Smith in the 1940s.

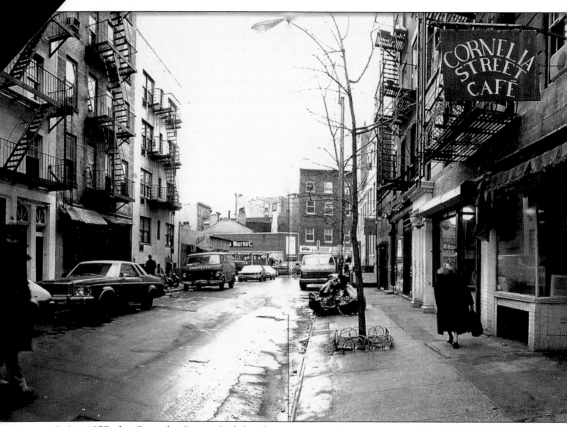

Since 1977, the Cornelia Street Café has been a venue for artists, musicians, and writers. It holds the distinction of being, by mayoral proclamation, a culinary and cultural landmark. (Courtesy Cornelia Street Café.)

Originally designed as a three-story structure in 1876 by John Franklin, No. 11 Cornelia Street was raised to five stories and converted from tenement apartments into studios in 1928. A narrow alley leads to a rear house. The facade was updated by James H. Galloway into a rough textured stucco and Mediterranean-inspired style with brick trim. Spanish tile cornices were added over the first floor and over the alley. The Seville Studios metal sign is still visible. Taking their cue from the Bohemian era, speculative developers created "artists' studios in many tenements and row houses."

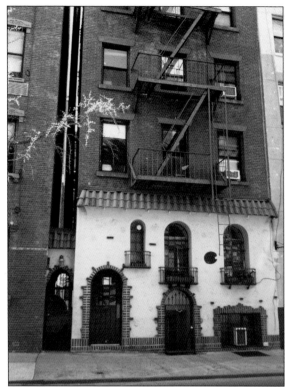

Nos. 6 and 8 Jones Street were built in 1871 by W.E. Waring. It was stuccoed at its erection, foreshadowing the later stucco rage in the 1920s. The awning above the second floor was added, as were small paned windows in the basement doorways.

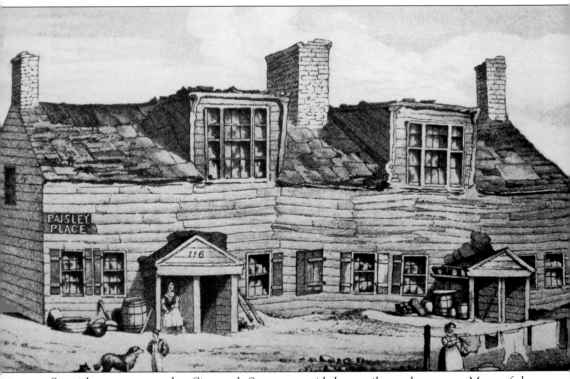

Scottish weavers moved to Sixteenth Street to avoid the pestilence downtown. Many of these top-notch weavers hailed from Paisley, Scotland, hence the name Paisley Place. Paisley is a center of the textile industry in Scotland. The teardrop-shaped paisley motif is Persian and Indian in origin. The western name for the design comes from the name of the Scottish town. (Courtesy New York Public Library Picture Collection.)

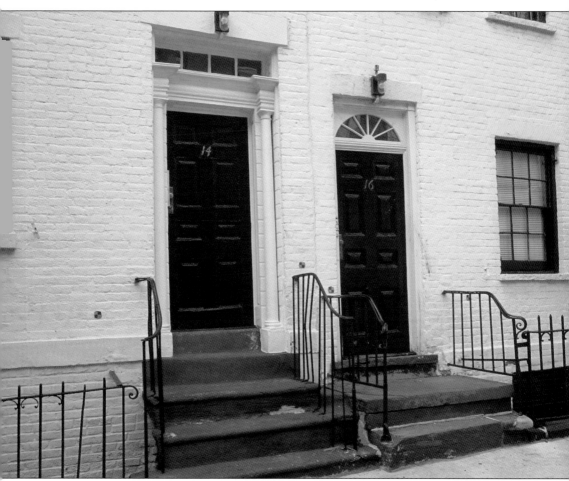

Nos. 14 and 16 Gay Street, both Federal-style houses, still stand in Greenwich Village. Scottish weavers reputedly lived here at one time. Accounts state that, later, the street's residents were mainly black, many of them servants of the wealthy white families on Washington Square. This also became noted as an address for black musicians, giving the street a bohemian reputation. The basement of No. 14 Gay Street was home to Ruth McKenney and her sister who came to New York from Ohio to seek fame and fortune. McKenney's tales *My Sister Eileen* became a Broadway play about two girls from Ohio who seek fame and fortune and live in Greenwich Village. "Here we are Christopher Street, Right in the heart of Greenwich Village" is one of the lines from the songs which appeared in a 1950s musical with Rosalind Russell based on the book and entitled *Wonderful Town.*

On the left, onlookers watch as renovations begin on No. 21 Astor Place, the old Mercantile Library. Below, No. 21 Astor Place is seen as it appears today. The old Astor Place Opera House once stood on this site. It was a popular venue for numerous gala events like the Firemen's Ball.

No. 36 Leroy Street is a very shallow three-story house with running bond brickwork. The date of construction is unknown.

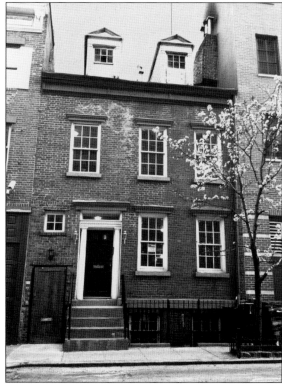

This charming little house at 7 Leroy Street was built in 1830–1831. It is a two-story wood house with a brick front. It has a former horse door on the left. No. 7 1/2 Leroy Street leads to an inner court and a two-story building in the rear.

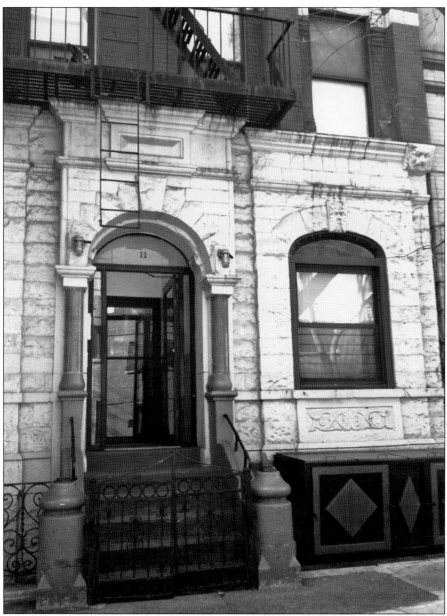

Nos. 11, 13, and 15 Jones Street were erected in 1889 by architect and first owner Adam Munch. They were old-law tenements, five-story brick buildings with stone first floors. Nos. 13 and 15 have been altered heavily; however, No. 11, seen here, remains intact. Old-law tenements (1879 to 1901) had a symmetrical floor plan that included four virtually identical apartments per floor, three rooms each, with the entry opening to the kitchen containing a washtub alongside a sink opposite a woodstove feeding into a flue. Two bathrooms were located on the landing in each hallway for common use; they had three-foot air shafts outside of windows, which provided just enough opening for ventilation, if not direct light. Tenement dwellers, however, tossed garbage, bilge water, and waste into these air shafts, which were not designed for garbage removal. A 1901 law did away with the air shaft, replacing it with a large courtyard for garbage storage and removal. In later structures, the introduction of elevators reduced garbage disposal by upper-story residents.

No. 17 Barrow Street is now an elegant restaurant known as One if by Land, Two if by Sea. In 1834, however, it was US vice president Aaron Burr's carriage house. Burr is best remembered for killing Alexander Hamilton, the first secretary of the treasury, in a duel in Weehawken, New Jersey, in 1804. While both men were contenders in the 1804 New York gubernatorial race, Hamilton wrote a scathing journalistic assault on Burr's character. Neither could retreat from his position, so a duel was arranged. At this time, dueling was being outlawed in the northern states. Burr was indicted for murder, although both charges were dismissed. Burr's grandson died at 10, and his daughter, Theodosia, was lost at sea while returning to New York from South Carolina in 1813. Theodosia's ghost has been reportedly been spotted in the restaurant. Burr is allegedly a visiting ghost in the former hayloft. He has also reportedly been seen at the Café Bizarre on West Third Street.

Nos. 26, 28, and 30 Jones Street were built in 1844 in the simple Greek Revival style. They have been registered as individual landmarks. Nos. 28 and 30 had one-story rear houses, and No. 26 was the original home of Greenwich House.

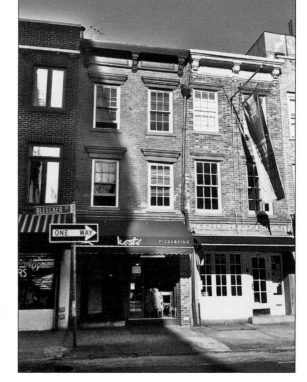

The very narrow houses at 267–269 Bleecker Street, built in 1836, were originally 2.5-story buildings that were converted from Federal-style homes into tenements. The facade was at one time heavily altered with stucco. The original owner was Charles Oakley.

The group of houses from 108 Waverly Place to 114 Waverly Place is unique to Greenwich Village. These four are all that remain of a row of nine built in 1826 for Thomas R. Mercein, president of the New York Equitable Fire Insurance Company. At the beginning of the 20th century, the artist Everett Shinn and his wife, the artist and metaphysician Florence Scovel Shinn, had a home and studio here at 112 Waverly Place.

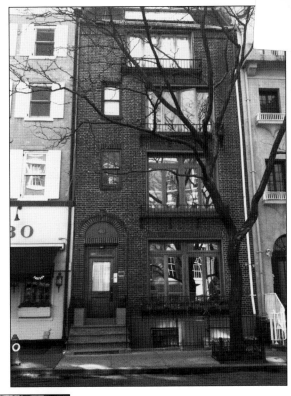

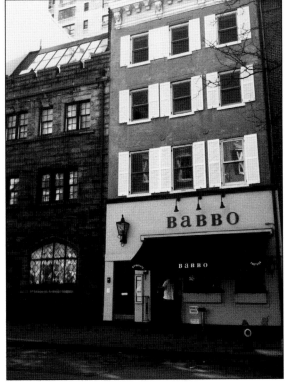

No. 110 Waverly Place is the only structure that retains a resemblance of its Federal-style origins. The fourth floor was added in character, as all the upper stories have the rectangular paneled lintels of the Federal period. The entrance has been completely altered as a restaurant, formerly the highly esteemed Coach House.

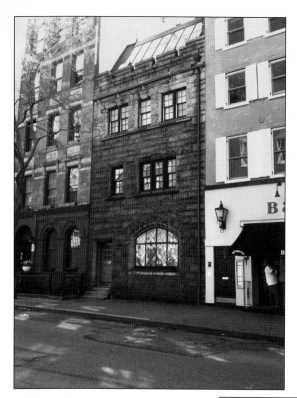

No. 108 Waverly Place was redesigned and altered by the American architect Charles C. Haight for Grace Wilkes in 1906. The renovations included a granite-faced, rough ashlar facade with a crenellated cornice. It is the only stone house in Greenwich Village. Haight's designs can be seen today at the General Theological Seminary, Yale University, and Trinity College, among other places. The roof over the attic floor was raised with a steeply sloped studio window. The present arched window at the ground-floor level replaced the former garage entrance. It was altered in 1927 for residents.

Pictured here is a letter from the Institute for Jazz Studies, at 108 Waverly Place, outlining its goals. The names on the left read like a who's who of contemporary notable figures in the arts. Former residents of No. 108 have included Richard Harding Davis, one of the most active and influential journalists during the Spanish-American War. It was also home to the screen star Miriam Hopkins. (Courtesy Nuri Akgul.)

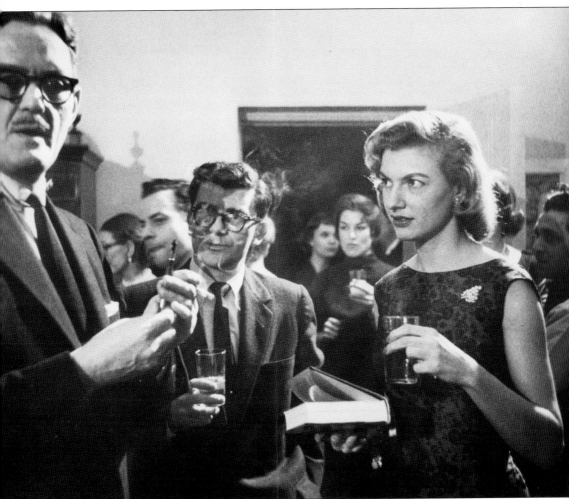

In 1952, Marshall W. Stearns founded the Institute of Jazz Studies. Among the jazz greats who helped develop the institute were Louis Armstrong, Dave Brubeck, Duke Ellington, Dizzy Gillespie, Benny Goodman, Woody Herman, and Artie Shaw. This photograph was taken at the party for Stearns's book, *The Story of Jazz*, published in 1956. At left, Stearns prepares to sign his book, while famed Indian sitar player Ravi Shankar can be see at the far right. (Courtesy Nuri Akgul.)

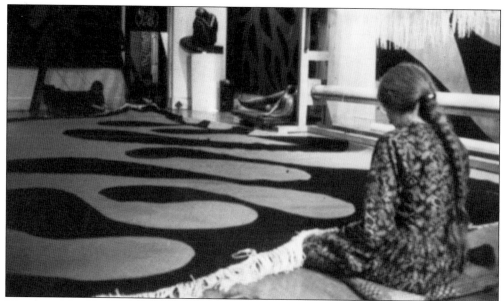

More recently, filmmaker, photographer, artist, and tapestry designer Jan Yoors and his family made 108 Waverly Place their studio and home. Here, Annebert Yoors finishes tapestry *Negev*, woven in the traditional Aubusson and Gobelin technique. It was commissioned by the architect Gordon Bundschaft. (Photograph by Jan Yoors.)

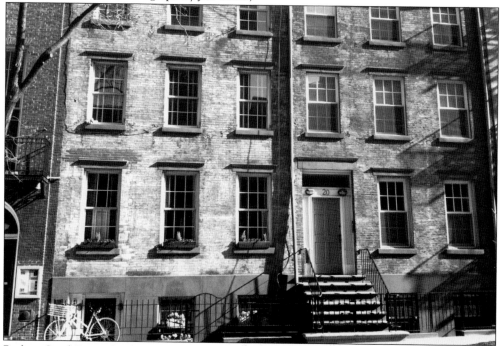

Built in Greek Revival style in 1845, Nos. 18 and 20 Jones Street have running-bond brickwork. No. 18 has a one-story rear building; No. 20 has a two-story rear building. It was owned by Greenwich House from 1919 to 1947. At one time, it was fashionable to remove the stoops and enter from the street level; however, the stoop at No. 20 was restored in the 1990s. The old brickwork marking the elevated entry can be seen around the far left window of No. 18.

Three

SCHOOLS, CHURCHES,
AND HOSPITALS

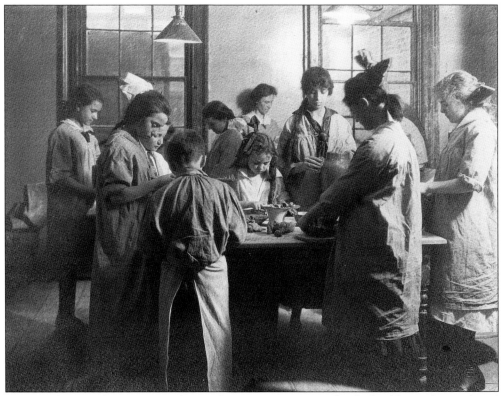

Greenwich House began as a settlement house in response to the deplorable conditions forced upon masses of immigrants who settled in Greenwich Village in order to work in the nearby factories. The Greenwich House pottery school was part of the program to enable local children to find recreation and a safe place after school. (Courtesy Greenwich House.)

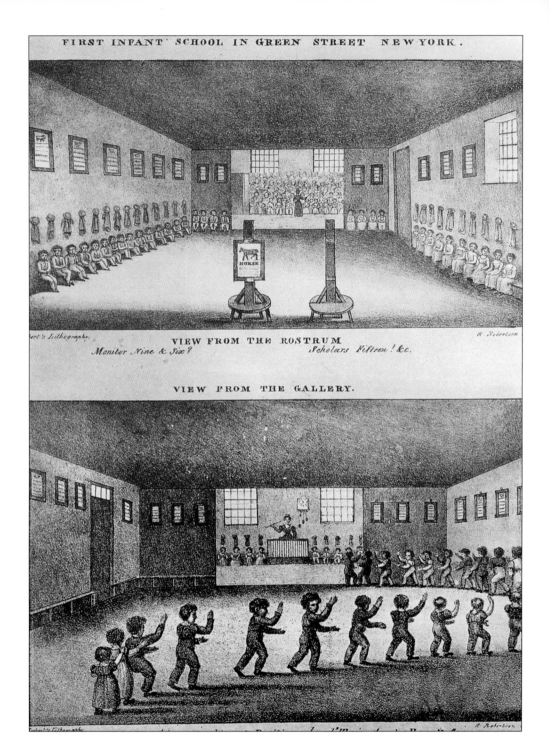

The Infant School in Green Street was one of the first schools devoted to children under five years of age. It worked to instill discipline and orderly conduct. Instructors also taught reading, writing, and arithmetic. (Courtesy New York Public Library Picture Collection.)

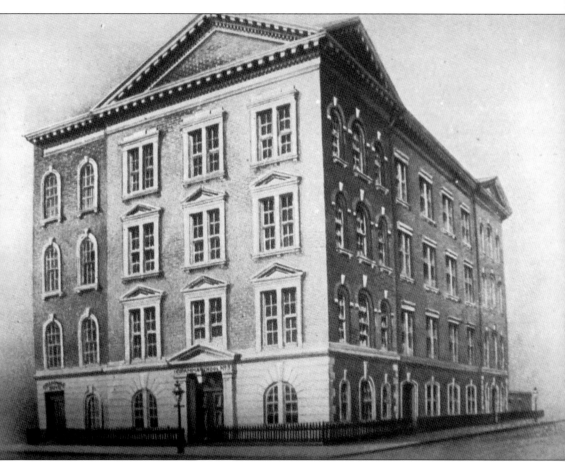

This image from an old *Valentine's Manual of New York* shows Public School No. 3 on Hudson Street. Today, the school still serves the Greenwich Village community as an elementary school. The present building was rebuilt at the turn of the 20th century. Recently, renovation workers discovered a time capsule from 90 years ago behind a wall panel. It contents are now housed at the New-York Historical Society. The present-day students inserted an updated time capsule from the 21st century. (Courtesy *Valentine's Manual of Old New York*.)

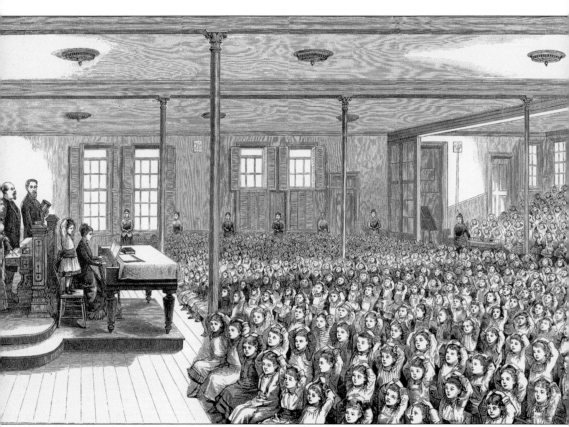

This scene is from a schoolroom in the Great Hall of the Cooper Union building on Astor Place. Important speeches have been delivered here, and speaking at the hall has been a contributing factor to greatness for many. Here, a child behind the piano accompanist demonstrates the calisthenic exercises that started off the day's program. (Courtesy New York Public Library Picture Collection.)

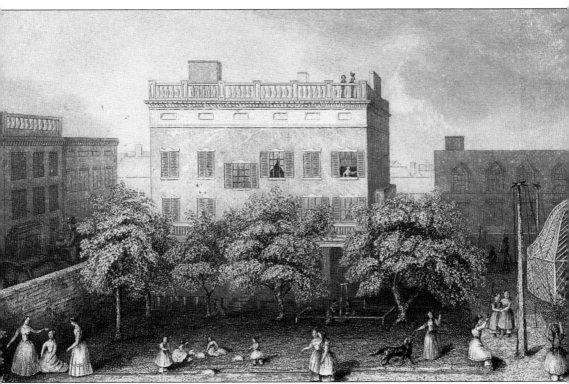

Pictured here is the Institution of Messrs. Abbott, a school for young ladies at 412 Houston Street in 1845. The building was taken over by the Sisters of Mercy in 1848 for their convent. The garden and house exactly covered the future site of the Puck Building. (Courtesy New York Public Library Picture Collection.)

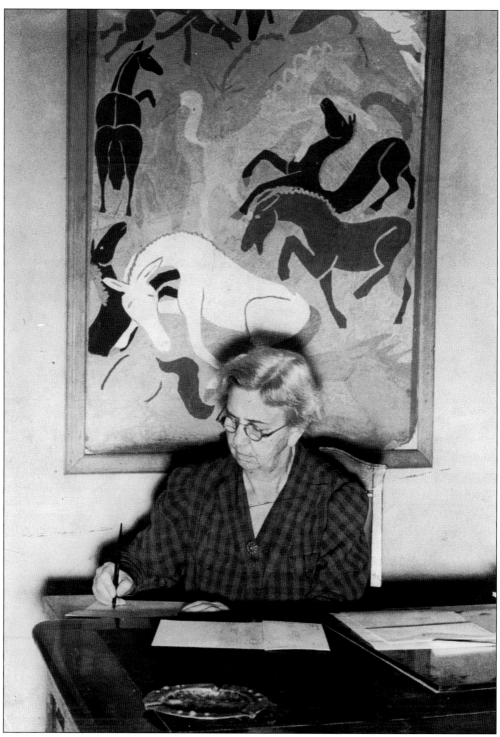

At the beginning of the 20th century, Greenwich Village gave birth to many innovative ideas. Among the pioneers in the field of education was Caroline Pratt, who created the City and Country School in 1914. (Courtesy City and Country School.)

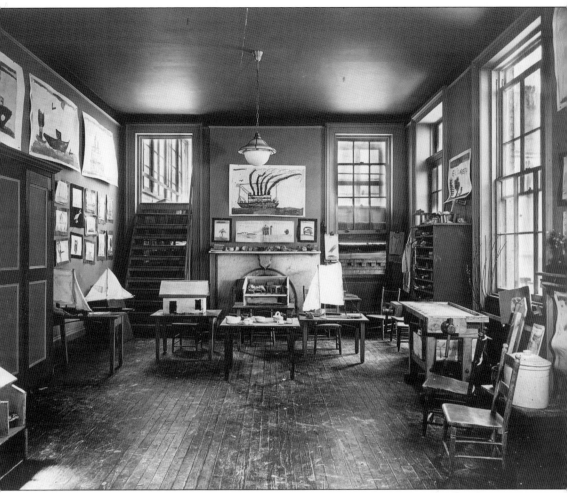

The City and Country School opened in a three-room apartment in MacDougal Alley during a dynamic period of progressive education. Soon after, Lucy Sprague Mitchell joined Pratt in her work, offering financial assistance that afforded larger quarters for City and Country's schoolhouse, as well as her own teaching expertise. (Courtesy City and Country School.)

Directly addressing what she observed as the mode of learning natural to children, Pratt developed alternatives to "the repression of formal education." (Courtesy City and Country School.)

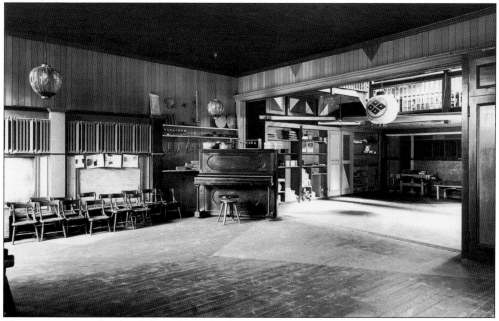

The progressive school's philosophy and educational program for children ages 2 through 13 continue to exert an important influence on educators nationwide and globally. The school moved to buildings purchased by Mitchell (and later sold to the school) on West Twelfth and Thirteenth Streets, where it remains today. (Courtesy City and Country School.)

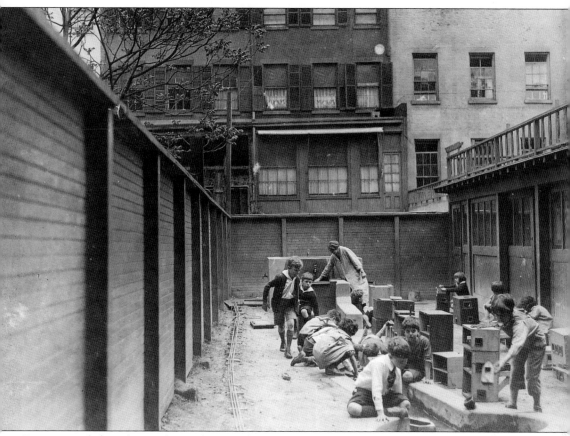

Pratt argued that the teacher's place is alongside the child, posing questions that promote imaginative thinking and help to develop problem-solving and decision-making skills in pursuit of a deeper perspective. The wooden unit blocks she developed for City and Country children ages two through seven were widely admired and copied. (Courtesy City and Country School.)

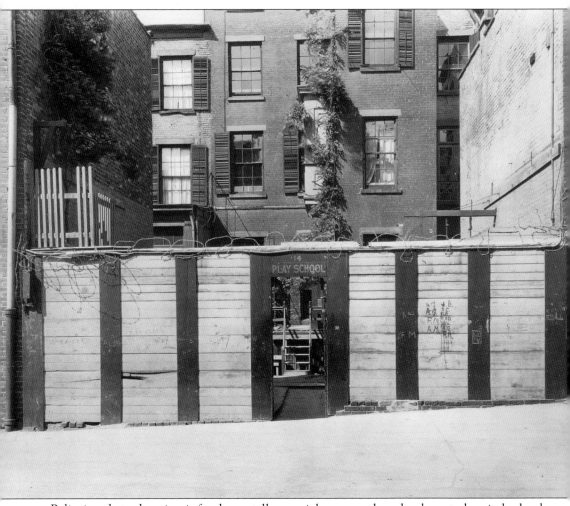

Believing that education is fundamentally a social process, the school created a vital school community that combined each child's innate passion for play and learning while also expanding his or her understanding of communities and cultures that exist beyond school and home. (Courtesy City and Country School.)

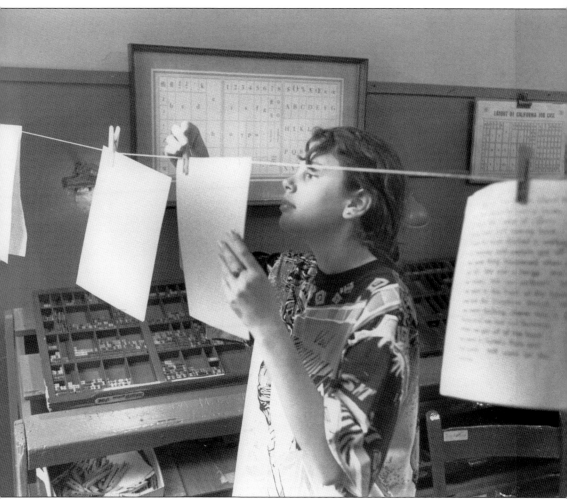

The school's basic materials and developmentally driven pedagogy attracted national interest and acclaim from many advocates, including noted educator and reformer John Dewey. The children used a hand-driven printing press to print their stories, poems, handmade greeting cards, and fliers for upcoming sales at the school store. Here, a student hangs up the printed work to dry. (Courtesy City and Country School.)

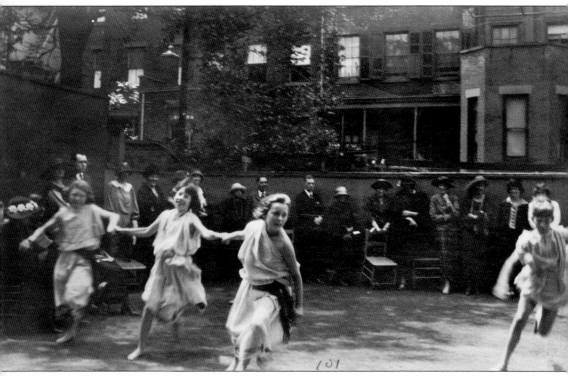

Caroline Pratt believed that the use of open-ended work materials offered children the opportunity to re-create the world around them and dramatize the events occurring in it. Here, students reenact a chariot race from their Ancient Greece Social Studies play on May 29, 1932. The dynamic nature of Caroline Pratt's educational legacy makes City and Country's program as relevant today as it was 95 years ago. (Courtesy City and Country School.)

The Tenth Street Studios was built in 1856 and was extant till 1954, when it was replaced by an apartment building called the Peter Warren, the name of which recalled an erstwhile landowner of early Greenwich Village. The studio was a novel idea at the time. The design by Richard Morris Hunt encouraged an "atmosphere of comradeship," according to Winslow Homer. Eminent artists John LaFarge, Emmanuel Leutze, Eastman Johnson, and Augustus Saint-Gaudens lived here. Edwin Booth posed for a statue here. As a child, Alexander Calder resided here; his father, A. Stirling Calder, created the sculpture *Washington as President, Accompanied by Wisdom and Justice* that adorns the west pedestal of Washington Square Arch. (Courtesy New-York Historical Society.)

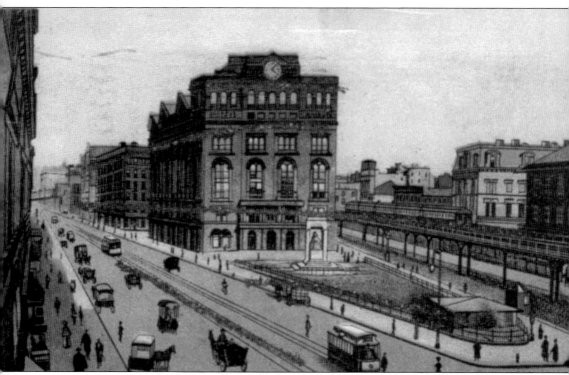

Cooper Union for the Advancement of Science and Art was built by the self-made millionaire Peter Cooper in 1859. Cooper made his fortune in Manhattan real estate and in iron rails made for the emergent railroads. He built the school across from his 1816 grocery on Stuyvesant Street. When it opened, it was the first free, nonsectarian, coeducational college. It continues that tradition today. (Courtesy Lisa K. Brugman.)

Abraham Lincoln was a senator from Illinois when he made his famous career-defining speech on February 27, 1860, at Cooper Union. He had worked on it for many months previous to its delivery. The reporters attending were at first uncomfortable with the gangly, awkward fellow from Illinois. After he began speaking, however, everyone in attendance listened with rapt attention. (Courtesy Library of Congress.)

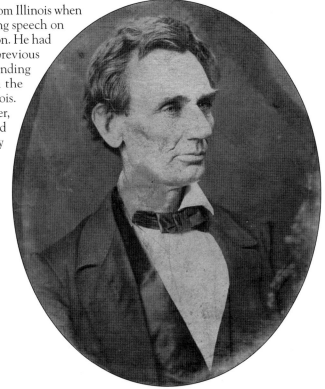

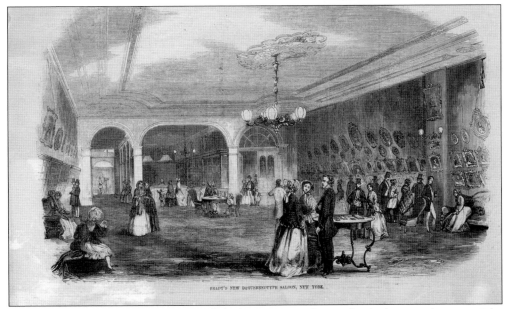

The famous photographer Matthew Brady had a portrait studio nearby. A photographic portrait by Brady almost assured that one had an eminent place in the society of the time, as he photographed many important historical figures, including Civil War generals, such as William Tecumseh Sherman and Ulysses S. Grant. Immediately after making his speech, Abraham Lincoln walked over to Matthew Brady's studio and had his picture taken. (Courtesy New-York Historical Society.)

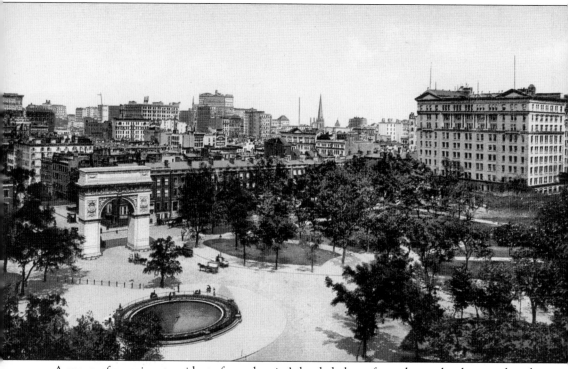

A group of prominent residents from the city's landed class of merchants, bankers, and traders established New York University on April 18, 1831. These New Yorkers believed the city needed a university designed for young men who would be admitted based on merit, not birthright or social class. The building at right still stands today. In the original University Building, faculty member Samuel Morse conducted his experiments in telegraphy and tenant Samuel Colt perfected the Colt revolver. The New-York Historical Society had its first home here. Dr. John William Draper, a professor of chemistry, made one of the first photographic portraits of the human face in 1840. Walt Whitman taught poetry, and Winslow Homer painted here. A fountain was placed in the square by the Society for the Prevention of Cruelty to Animals for the tired horses pulling carts and coaches. (Courtesy Lisa K. Brugman.)

The New School for Social Research was founded in 1919 by a group of intellectuals, some of whom were teaching at Columbia University during the First World War. Fervent pacifists, they took a public stand against the war and were censured by the university's president. The professors responded by resigning from Columbia and later opening up their own university for adults. Their aim was to create a place where people could exchange ideas freely with scholars and artists representing a wide range of intellectual, aesthetic, and political orientations.

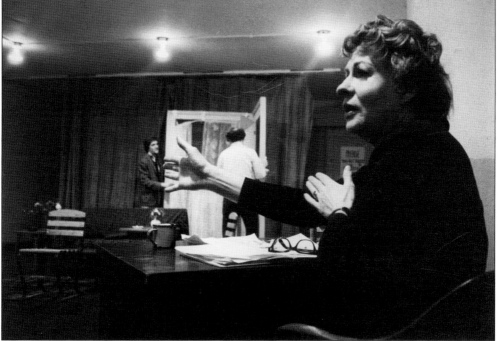

"Uta Hagen, the cofounder of HB Studio at 120 Bank Street, was one of the most dynamic teachers I have ever encountered," says former student Pamela Shandel. "She was remarkable because she taught and spoke to the soul of each individual. Her light force was immense. Her passion was like sparkling stars. Her effect on you: you were lifted up forever. Uta was my mentor. She taught me about acting, yes. But most importantly, she taught me to recognize the individual spirit in myself that was aching to express itself, and to honor that. No matter who the student, she guided us to be better performers, better actors, and, most importantly, better human beings. Uta's integrity was the sun. Solid, strong, and penetrating." (Photograph by Pamela Shandel.)

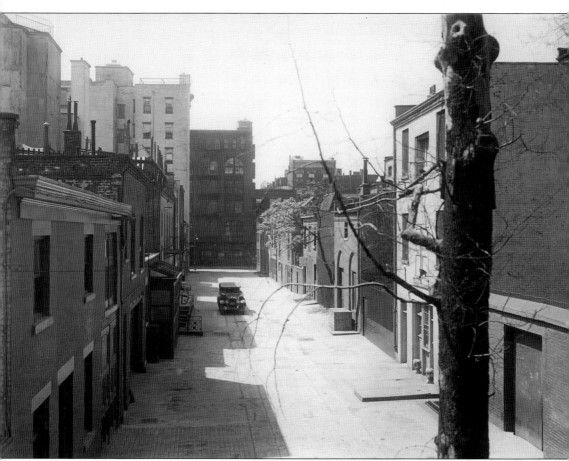

In 1917, the stables of MacDougal Alley attached to the stately homes on Washington Square North and Eighth Street were being converted into artists studios. For a short time, the alley was home to City and Country School. The building facing the alley became the Tenth Church of Christ, Scientist in 1921. During a recent renovation, the original facade was discovered intact beneath the modernist exterior, which had been applied in the 1960s. It now resembles the original factory building seen here. At the right far end of the alley was the popular night spot The Jumble Shop, where the owner chilled his store of wine bottles tied together with a rope in the Minetta Stream which flowed below in the cellar. (Courtesy City and Country School.)

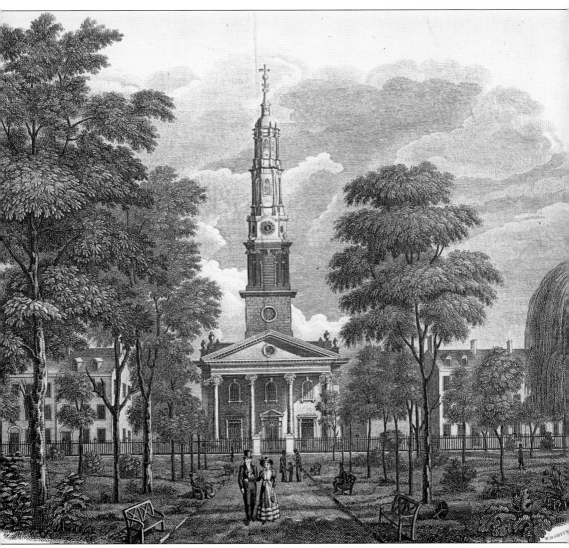

St. John's in the Park, an engraving of the chapel, appeared in *The New-York Mirror* in 1829. Built in 1803, the church stood 214 feet high on Varick Street in one of the most fashionable districts of the time in the city. It was a chapel in the Episcopal parish of Trinity Church. In the 1870s, the New York Central Railroad bought the park to build a downtown freight terminal on the site. The church was demolished in 1890. (Courtesy New York Public Library Picture Collection.)

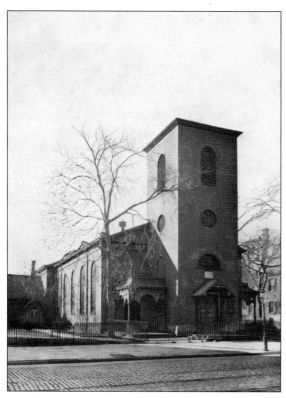

On October 22, 1820, a small group of residents of the riverfront village of Greenwich gathered to organize an Episcopal church for their growing community. They named it after St. Luke, the physician evangelist, in recognition of the village's role as a refuge from the yellow fever epidemics that plagued New York City during the summers. The Church of St. Luke in the Fields was consecrated in 1822 and stands at 487 Hudson Street. (Courtesy New York Public Library Picture Collection.)

The cornerstone for this building, St. Mark's-in-the-Bowery, was laid in 1799, on the site of the former governor of New Amsterdam Peter Stuyvesant's home chapel. He is buried in a vault beneath the church. Architect Ernest Flagg designed the rectory. It is constructed of schist, a dull grey stone readily available from the bedrock of Manhattan. This kept the building costs down and eliminated the need for quarried stone. (Photograph by Edward Wenzel, courtesy New-York Historical Society.)

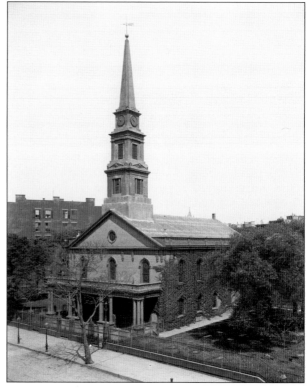

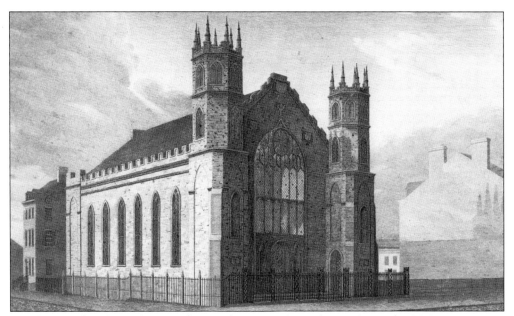

St. Thomas Church stood at Broadway and Houston Street from 1824 until 1870. Its importance was bolstered by the fact that it held two cisterns that aided volunteer firemen in fighting fires. When the neighborhood deteriorated, it moved to its present site at Fifty-third Street and Fifth Avenue in 1870. (Courtesy New York Public Library Picture Collection.)

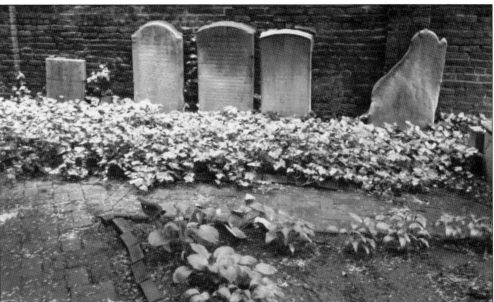

This is the Second Cemetery of the Spanish and Portuguese Synagogue Shearith Israel in the City of New York. Shearith Israel was the only Jewish congregation in New York City from 1654 until 1825. During this span of history, all of the Jews in New York belonged to the Congregation Shearith Israel, which was founded by 23 Jews, mostly of Spanish and Portuguese origin. Burials began here in 1805, in what was a much larger, square plot extending into what is now the street. The Commissioners' Plan had established the city's grid in 1811, but not until 1830 was West Eleventh Street cut through, at that time reducing the cemetery to its present size.

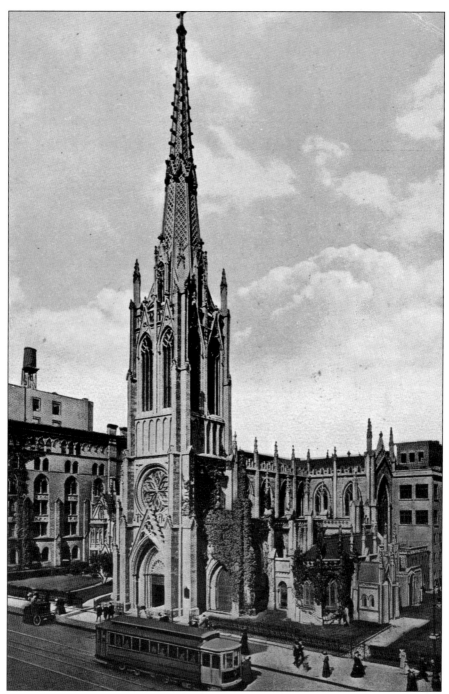

Grace Church stands on land purchased from Henry Brevoort Jr., who sold the church lots from his family's old farm between Tenth and Eleventh Streets. A young James Renwick, fresh from his job as supervisor at the Croton Reservoir at Forty-second Street, was chosen as architect. His work can be seen at the Smithsonian Institution, the main building of Vassar College, the Corcoran Gallery in Washington, and St. Patrick's Cathedral. (Courtesy New York Public Library Picture Collection.)

The Middle Dutch Church on Lafayette Place, completed in 1839, was a classic Greek Revival church and perhaps the best example of work by noted architect Isaiah Rogers. The Dutch Reformed (Collegiate) denomination was wealthy enough to move as soon as the neighborhood ran down. The church was evacuated in 1887 and soon thereafter demolished. (Courtesy New York Public Library Picture Collection.)

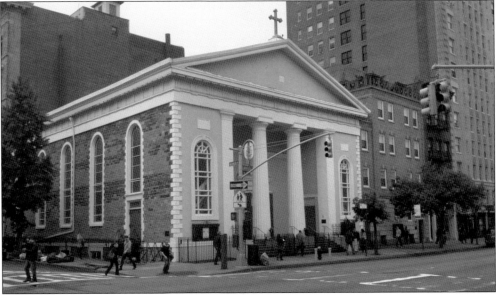

St. Joseph's Parish was founded by Bishop John Dubois in 1829. The cornerstone of the Church was laid on June 10, 1833. The present structure is the original one and, consequently, St. Joseph's Church has the distinction of being the oldest Catholic church edifice in Manhattan. Architect John Doran succeeded in harmoniously combining a strong Greek Revival style with numerous Gregorian features. St. Joseph's Academy, an elementary school abuts, to the left on Washington Place. Early church records indicate that St. Joseph's first congregants were predominantly Irish Americans. During a recent renovation, an original mural was discovered behind the plastered wall. It has been restored and is now on view.

The Brevoort Hotel, located at Eighth Street and Fifth Avenue, is pictured in its heyday in the early 20th century. One of the oldest and most famous hotels in New York, it was a favorite meeting place before being demolished in 1954. (Courtesy Lisa K. Brugman.)

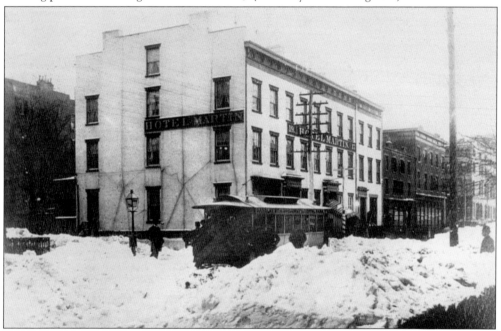

Hotel Martin stood on the corner of Ninth Street and University Place. During the blizzard of 1888, it kept its clientele well fed, thanks to the French owner's scrupulous demand for the finest ingredients, which he kept on hand in great quantities for his guests.

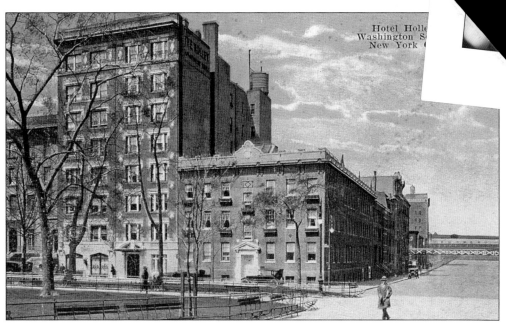

Hotel Holley, offering rooms and apartments at 35 Washington Square West, was an eight-story, 92-foot-high brick building overlooking Washington Square Park. The notorious "hanging tree" is, according to local lore, located on the northwest corner of the park. The elevated railroad on Sixth Avenue can be seen at the end of Washington Place on the right. When the building to the right of the hotel was torn down and the present-day Hayden Hall dormitory for New York University students was under construction, the Minetta Brook below forced construction to halt. Water was pumped out. The next day, the same amount of water was found. Special engineers had to be called in to deal with the situation.

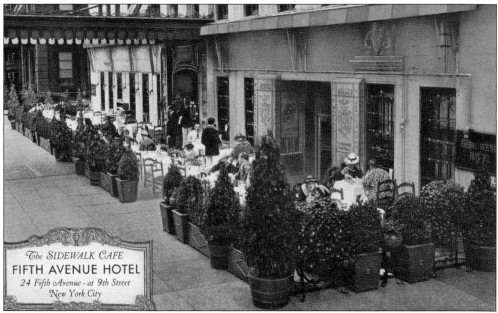

Across the street from the Hotel Brevoort was the Fifth Avenue Hotel, with its Sidewalk Café, located at 24 Fifth Avenue. It is pictured here in the 1930s. (Courtesy Lisa K. Brugman.)

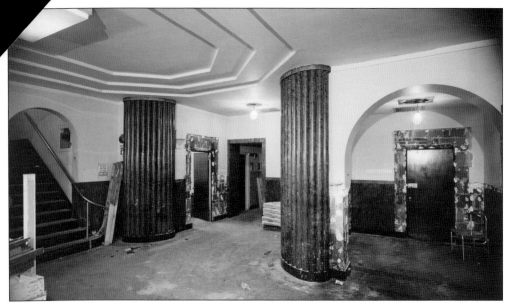

With marble-covered columns, the lobby the Leon Lowenstein Clinic at St. Vincent's Hospital is pictured in preparation for its opening in 1979. (Courtesy Library of Congress.)

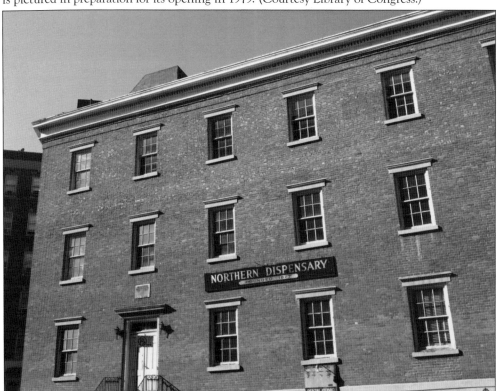

Northern Dispensary is the second-oldest medical institution in the city. Its deed stipulates that it can only be used as a medical facility for the indigent. It has functioned as a medical, dental, and AIDS facility. The triangular building at the crossroads of Christopher Street, Waverly Place and Waverly Place stands vacant in 2011. (Courtesy Library of Congress.)

Four

CIVIC AND MUNICIPAL SERVICES

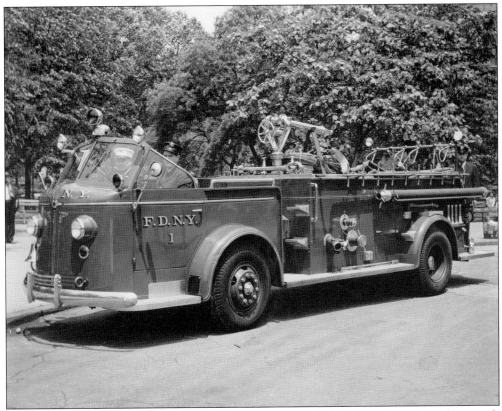

This 1940s fire engine is just one of the trucks that was used to fight fires throughout Greenwich Village. (Courtesy New York Public Library Picture Collection.)

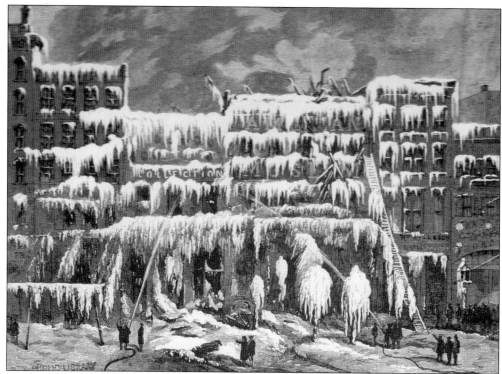

P.T. Barnum's second museum opened on Broadway in November 1865. On the night of March 2, 1868, the new museum burned. The fire occurred on one of the coldest nights of the year, causing the water from the firemen's hoses to freeze and form giant icicles as soon as it hit the walls. This drawing was done by Stanley Fox. (Courtesy New York Public Library Picture Collection.)

The Triangle Factory fire, seen here, occurred on March 25, 1911, on Washington Place. (Courtesy Library of Congress.)

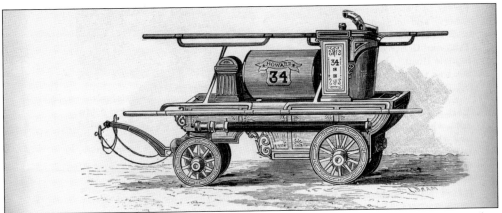

Fire Engine No. 34 was used by the Howard "Red Rover" Department, which was organized in 1807. In 1813, it was located on Amos Street; in 1820, it was on Gouvernor Street; in 1830, it was located at Hudson and Christopher Streets; and in 1864, it moved to 78 Morton Street. Among the names of the volunteer firemen were Abraham G. Depew, blacksmith, foreman, 1824; and Moses Springer, painter. (Courtesy New York City Fire Museum.)

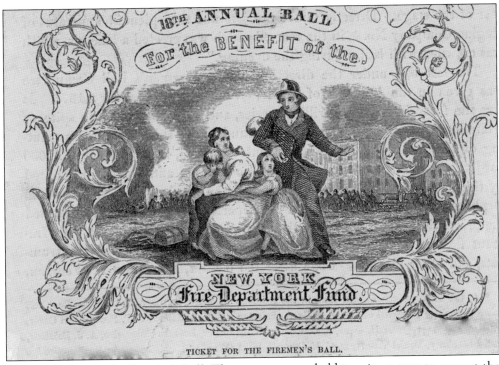

TICKET FOR THE FIREMEN'S BALL.

This is a ticket to the Firemen's Ball. These events were held to raise money to support the needy. They were gala affairs that were often held at the Opera House on Astor Place, the Academy of Music, the Park Theatre on Park Row, or Niblo's. (Courtesy New York Public Library Picture Collection.)

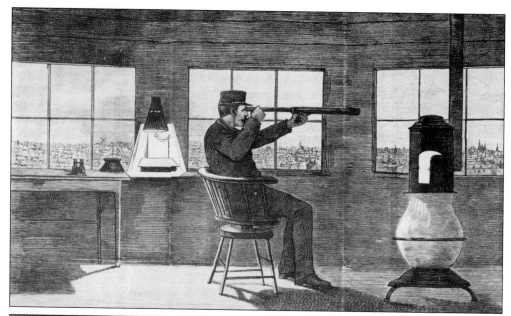

This fire watcher on the city's second iron fire tower at Varick and Spring Streets scans the horizon for fires. The watchman discovered fires through his telescope and then gave the alarm by strokes on a huge bell, which alerted the volunteer firefighters to the general whereabouts of the fire. They often spent precious time running around a designated fire district in order to find the fire. This drawing was done by Winslow Homer. (Courtesy New York Public Library Picture Collection.)

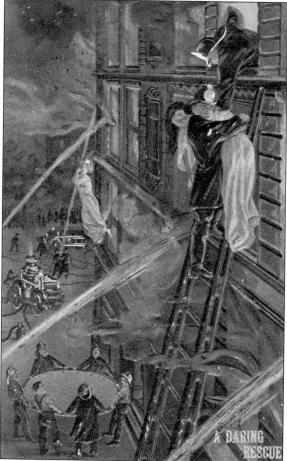

Fire rescue in the 1800s is documented in this painting. It was said that New York suffered more frequently from conflagrations than any other city except Constantinople. One could not go 24 hours without hearing an alarm. However, many of these were false alarms raised by boys for the pleasure of running after the engines.

The Firemen's Hall Mercer Street headquarters is depicted here in 1854. (Courtesy New York Public Library Picture Collection.)

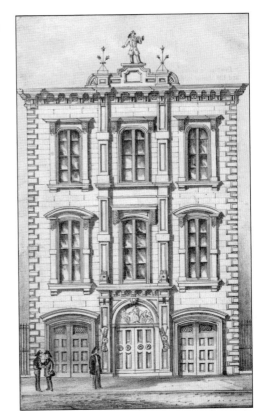

Telegraphs, such as this one at Mercer Street Firemen's Hall, improved communication, directing firemen closer to the site of a blaze. This one remained in existence for many years. Fireboxes were also used to report fires. (Courtesy New York Public Library Picture Collection.)

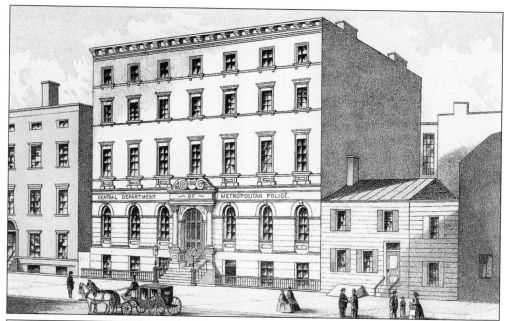

The metropolitan police headquarters on Mulberry Street, near Bleecker Street, is depicted in 1863. This drawing is taken from *Valentine's Manual of Old New York*. (Courtesy Pageant Print Shop.)

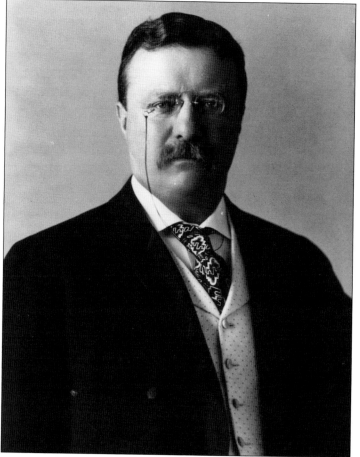

Before 1901, the New York Police Department was managed by a board of four to six commissioners who jointly ran the department. Theodore Roosevelt served as superintendent from 1895 to 1897. In one of his final acts before becoming vice president in March 1901, Gov. Theodore Roosevelt signed legislation replacing the police board and office of police chief with a single police commissioner. (Courtesy Library of Congress.)

The Jefferson Market Courthouse is pictured as it appeared in 1935. Today, the courthouse is the local branch of the New York Public Library Picture Collection. The bell in the tower was once used as an alert for fires, and for this reason it has a very unusual tone. (Courtesy New York Public Library Picture Collection.)

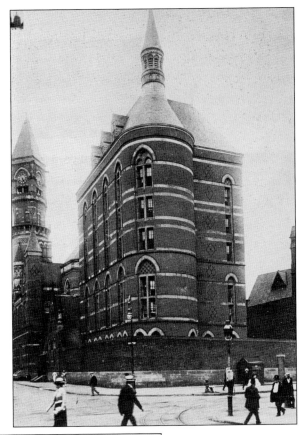

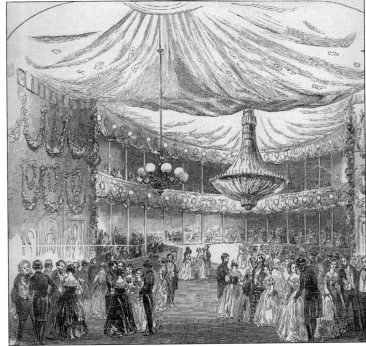

During the mid-1800s, the annual Firemen's Ball, in aid of the Widows' and Orphans' Fund, was held at Astor Place Opera House and the Academy of Music, among other venues. It became one of the most notable events of city life and was eagerly attended by those of wealth, industry, intelligence, and enterprise in New York. Carefully executed decorations and as many as 100 musicians accompanied the popular event.

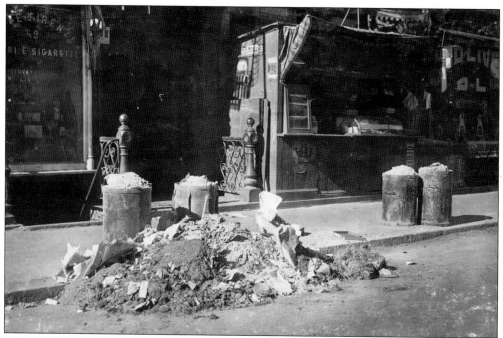

Garbage had always been a problem in New York City. In early years, the city was full of loose pigs; they ate gardens and crops and fought with dogs for the garbage thrown out the windows into dooryards. (Courtesy Library of Congress.)

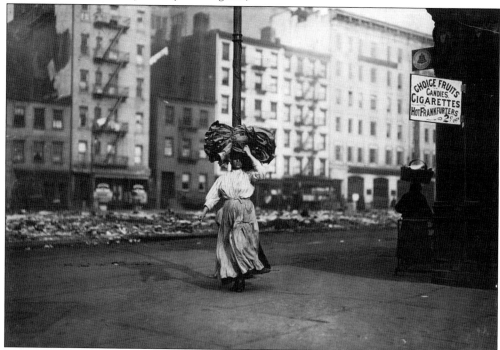

This woman was photographed picking up piecework near Astor Place. Behind her, litter lines the street. In residential areas, homeowners were ordered to sweep the street in front of their residence twice a week. (Courtesy Library of Congress.)

The caption turned in by photographer Lewis W. Hine for this 1905 New York City image reads, "A happy note in the old tenement life. Child is bathed and underwear is laundered at one time." Tenement apartments often had a communal bathing facility, or tenants used the public baths. (Courtesy New York Public Library Picture Collection.)

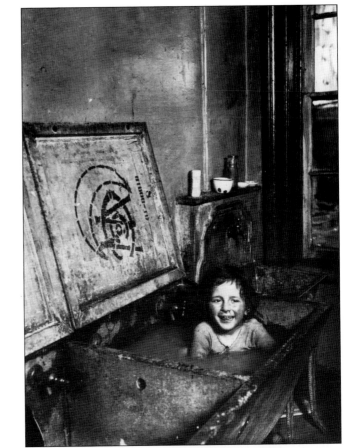

Progress against the war on garbage was made when the city hired street cleaners equipped with small barrel-shaped carts. They brushed the street clean with the help of water from hydrants. (Photograph by Jan Yoors.)

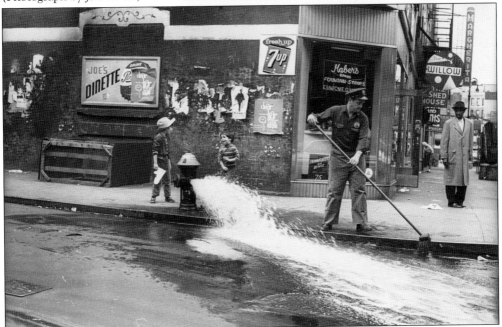

Robert Fulton sailed the *Clermont*, a paddle-wheeler known as "Fulton's Folly," in its first public display from a wharf at the end of Christopher Street. Having the first commercial success using one, he brought these vessels from the experimental stage to profitable use.

The *Hendrick Hudson*, a steamer in the fleet of the Hudson River Day Line, started its sail north from a pier near Greenwich Village. At 391 feet, it was the second-largest vessel in the line and carried up to 5,550 passengers. Thanks to the Erie Canal, it could travel to Buffalo before returning to Albany and New York City.

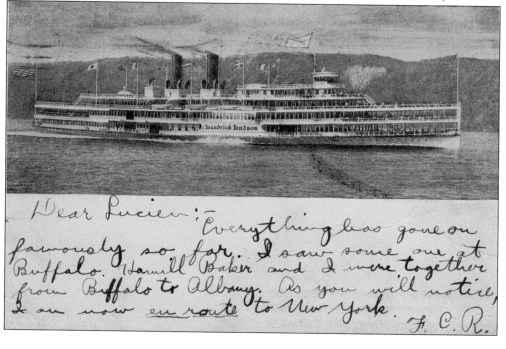

Dear Lucien:— Everything has gone on famously so far. I saw some one at Buffalo. Harrill Baker and I were together from Buffalo to Albany. As you will notice, I am now *en route* to New York. F. C. R.

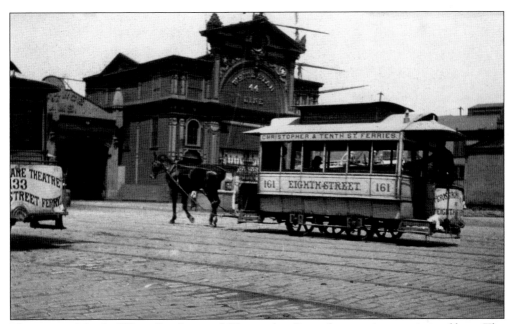

The terminal for the White Star Line and Christopher Street ferry station are pictured here. The *Lusitania* set sail from here on its fateful journey that contributed to America's entry into World War I. (Courtesy New-York Historical Society.)

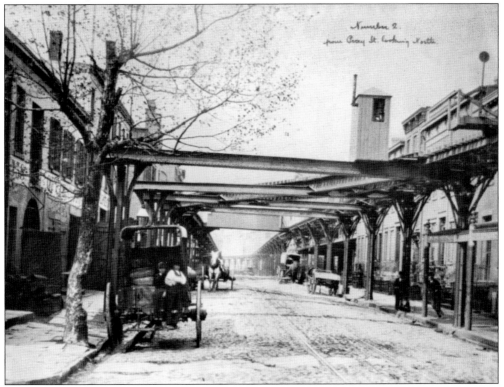

This photograph captures the Perry Street elevated train line, which was another popular means of transportation for city residents.

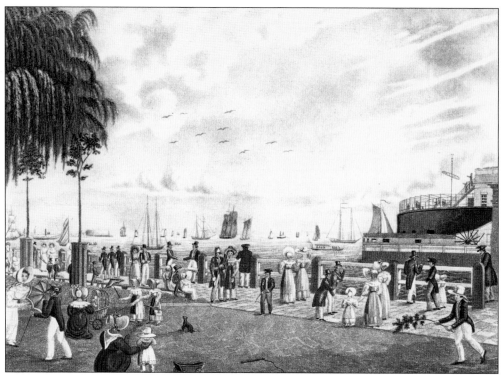

This sketch of the Hudson River Promenade provides an idea of how earlier residents enjoyed a stroll along the shore of the Hudson River before freight piers were built along the water's edge. (Courtesy New York Public Library Picture Collection.)

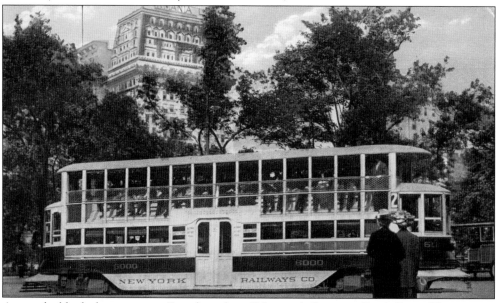

A new double-deck car runs on Broadway from Fifty-ninth Street to South Ferry. This car was designed for convenience and comfort. The steps were designed to be only three inches from the ground, and the entrance was located in the center of the car, so the vehicles were easy for all riders to board.

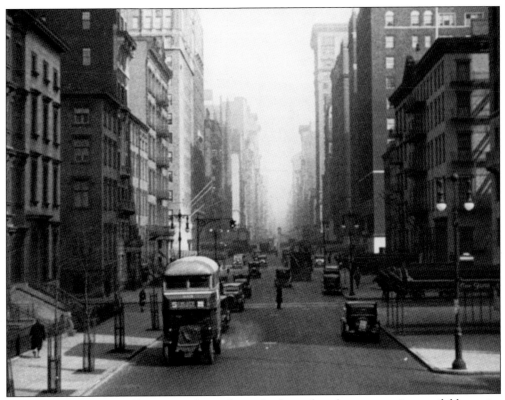

This view looking up Fifth Avenue shows the multiple modes of transportation available to city residents. (Courtesy Greenwich Village Society for Historic Preservation.)

Before the opening of the Croton Aqueduct in 1842 as a water supply for the city, water was one of the chief commodities for barter. Knapp's Tea Water Pump (depicted) at Tenth Avenue and Fourteenth Street was the most popular for those who could afford it. The tea well at Christopher Street and Sixth Avenue came in second, as it was also a bubbling spring of fresh cold water, unlike others in the lower parts of the city, which delivered a brackish substitute. Lack of clean drinking water was one cause of the devastating epidemics that plagued New York.

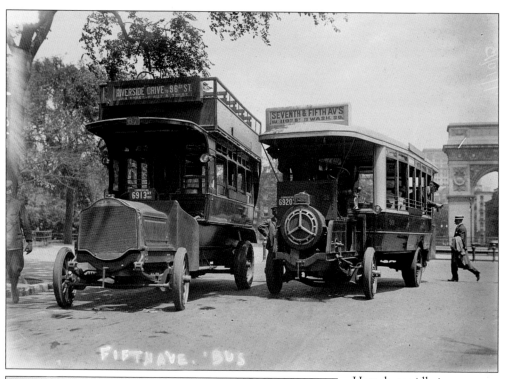

Here, buses idle in Washington Square Park at the end of the run. (Courtesy Library of Congress.)

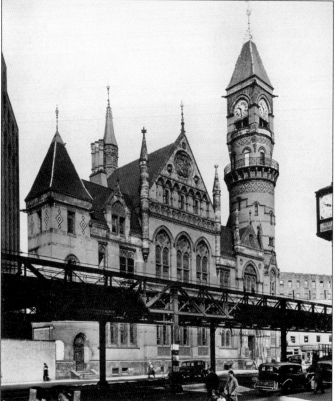

Jefferson Market and the elevated train are pictured from the southwest corner of Sixth Avenue and West Tenth Street. This view was taken looking north from the southwest corner of Ninth Street on October 21, 1935. (Courtesy New York Public Library Picture Collection.)

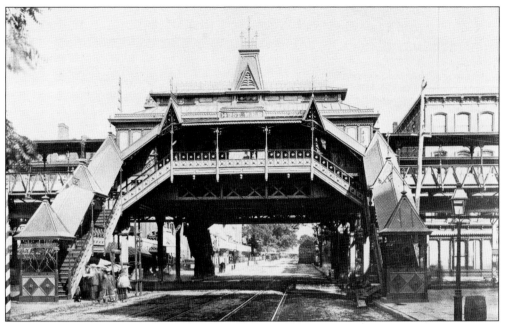

The Metropolitan elevated railroad station at Fourteenth Street and Sixth Avenue is pictured around 1879. To the right of the image is the R.H. Macy store at the southeast corner of Sixth Avenue. (Courtesy New York Public Library Picture Collection.)

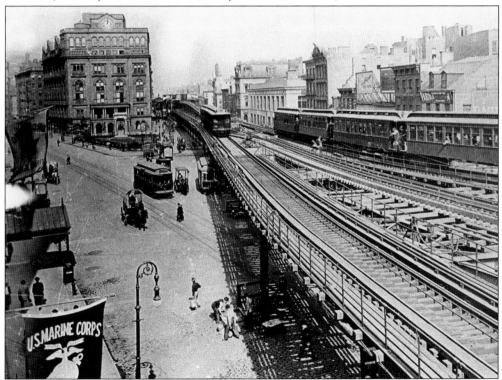

Astor Place is pictured here with trains. Litter is no longer in evidence. The newspapers extolled the speed with which riders were carried to their destinations. (Courtesy Lisa K. Brugman.)

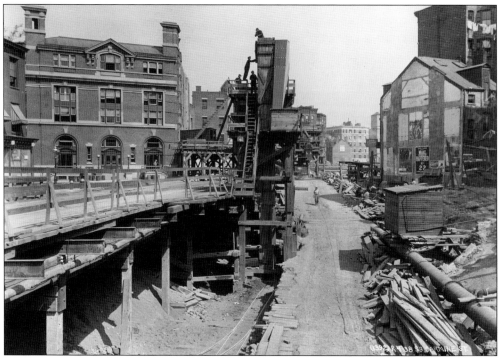

The Seventh Avenue subway excavation at Carmine Street is captured in this September 2, 1914, photograph. Parts of buildings were sliced off to carve out a straight avenue. (Courtesy New-York Historical Society.)

THIS SHOWS the Liberty Pole erected for firemen's contests near Riley's Hotel at the southwest corner of Franklin Street and West Broadway, Manhattan. Riley's Pole was one of the more popular of the locations where the skill of companies and the playing power of their engines were put to test. Companies were extremely jealous of the reputation of their engines and often issued or accepted challenges to prove their merit on a certain holiday, Thanksgiving Day being frequently chosen for this occasion. Riley's Pole was said to stand one hundred and thirty-seven feet in the air and was marked at various places so that the judges, comfortably seated on Riley's roof, could report the heights attained by the contestants.

Riley's Liberty Pole was first erected in 1834 on Washington's birthday. The following year it was struck by lightning and another was put in its place. In 1858, long after the old-timers had ceased to gather at this spot to recall fond memories, the Pole was removed.

· 2 · · 3 ·

This image shows the tournament rules of the Firemen's Associations for the State of New York.

Five

BUSINESSES AND
ENTERTAINMENT

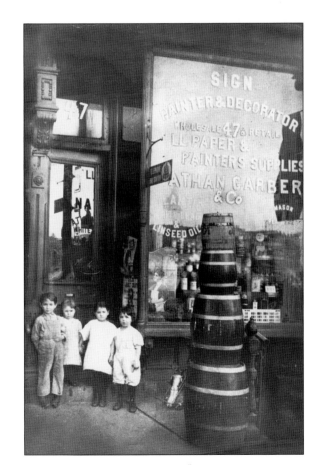

Garber Hardware Store is shown
around 1908. Pictured are, from left
to right, Ralph, sisters Anna and
Sylvia, and brother Benny Garber.
Reflected in the mirror in the
store window is their mother, Katie
Garber, with Henry in a stroller.
The barrels tell of the Garber
family history as barrel-ring makers.
(Courtesy Garber Hardware.)

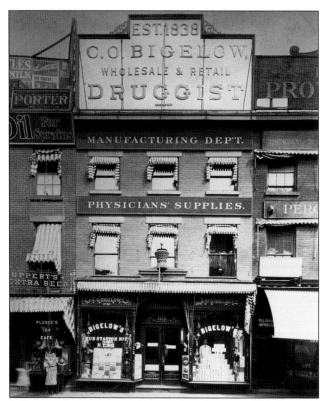

C.O. Bigelow's Pharmacy, at 102 Sixth Avenue, is pictured here. The store was founded by Galen Hunter, MD, a native of Vermont, in 1838. (Courtesy C.O. Bigelow's.)

Pictured is the West Street Market. Although this photograph was taken farther downtown, this market resembles the markets at the Gansevoort and Washington Market near Christopher Street and the Hudson River, and later the Jefferson Market, located at the site of today's Jefferson Market Library.

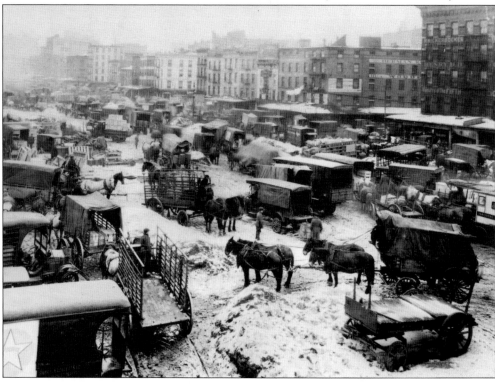

The Longo Bakery at 201 Bleecker Street is seen around 1940 in a tax photograph. (Courtesy Peter Longo.)

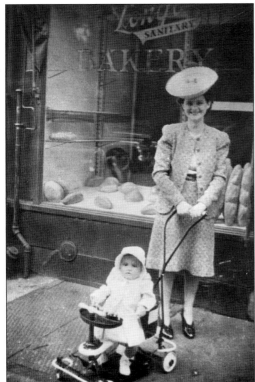

Rose Longo and her son Peter, the present owner of Porto Rico Importing Company, stand before the family's original store, the Longo Sanitary Bakery. (Courtesy Peter Longo.)

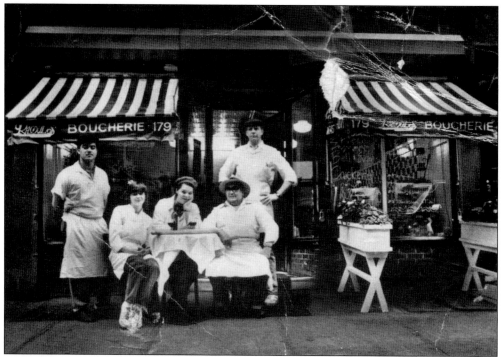

This is Raoul's Boucherie at 179 Prince Street. Mexican butcher Alonso Monteil, seated to the right, started at the Prince Street Boucherie and later carved meat at the Florence Meat Market. (Courtesy Florence Meat Market.)

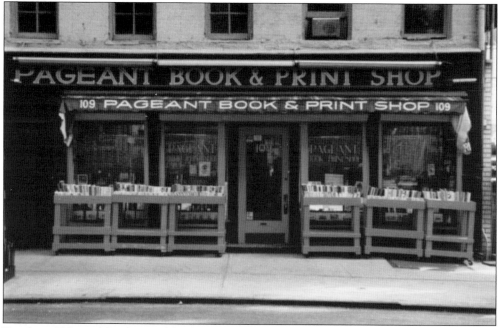

For about 100 years, bookstores like the Pageant Book and Print Shop, located at 109 East Ninth Street, lined Fourth Avenue and nearby streets between Ninth and Fourteenth Streets. (Courtesy Pageant Print Shop.)

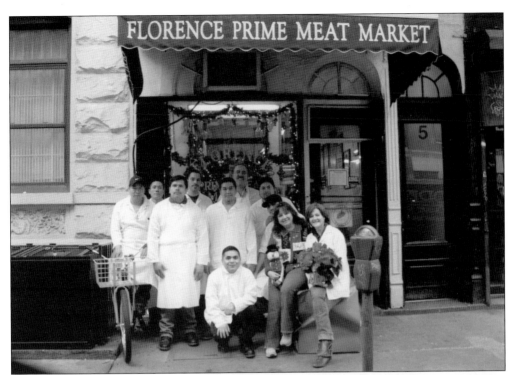

This is the Florence Meat Market, the favorite butcher of Jackie Onassis. She had their famous Newport steaks delivered uptown to her residence at Fifth Avenue and Eighty-fifth Street. (Courtesy Florence Meat Market.)

Zito's Bakery was photographed by Berenice Abbot at 259 Bleecker Street on February 3, 1937. Tasty breads from Zito's were a staple for villagers from the baker's establishment in the early the 1900s. Founded and operated by the Zito family for generations, it closed its doors in 2006. The secret to their delicious bread recipe was a dollop of oil thrown into the dough by an early Portuguese baker. This recipe guaranteed that their bread remained unique among the Italian bakeries. (Courtesy Museum of the City of New York.)

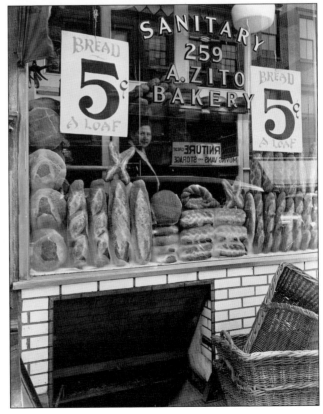

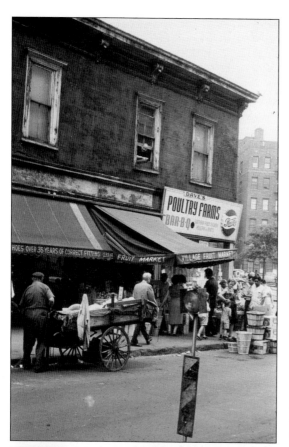

Art and commerce coexisted on Bleecker Street in the 1940s and 1950s. Artist and dentist Dr. Frank looks out of his window at the Italian neighborhood's fruit and vegetable vendors below. This building at 237 Bleecker Street is thought to be the inspiration for Edward Hopper's painting *Early Sunday Morning*. (Photograph by Jan Yoors.)

The Nusraty Afghan Store was started 30 years ago by Abdul Nusraty and his wife, Raofa, shown here with their baby son, Jawad, after fleeing civil war in Afghanistan. The shop was located at 115 West Tenth Street. (Courtesy Nusraty.)

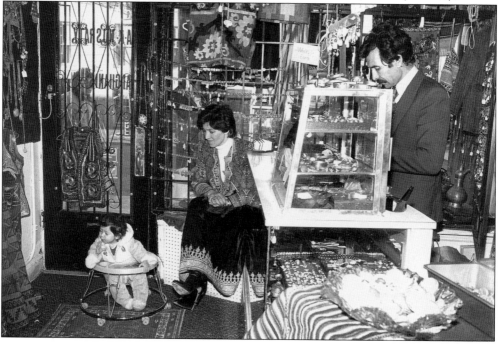

AT&T operators and the pyramid switchboard are pictured in 1888. Bell Laboratory originally occupied the building at Bethune, Washington, West, and Bank Streets. It now houses artists in the newly landmarked building, the Westbeth. (Courtesy AT&T.)

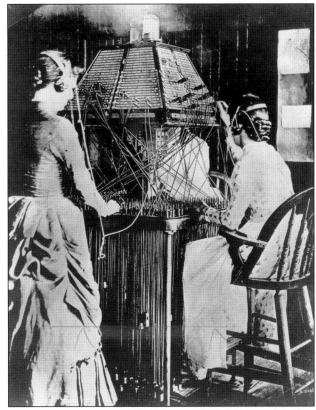

This furniture store card is just one example of the many manufacturers that were located on Broadway east of Washington Square in the 1800s and early 1900s.

The Hale & Kilburn Manuf'g Company,

Sole Manuf'rs of the "Champion" Automatic Folding Bedstead

Thousands already in use, and very many more sold during the last year than any time before.

Simple in Construction, Handsome Designs, Elegant Finish.

THERE IS NONE EQUAL TO IT.

"Peerless" Reservoir Washstand.

"Flexible" Spring Beds.

"Unique" Odorless Commode.

Child's Chariot Chair.

—706—

B'dway.

Other Specialties in Furniture

Visit our Wareroom.

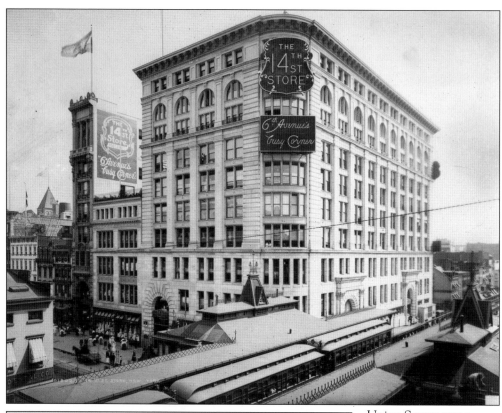

Union Square was a great shopping area. The Fourteenth Street Store is pictured above. Later the famous discount store Klein's attracted bargain shoppers at this location. (Courtesy Greenwich Village Society for Historic Preservation.)

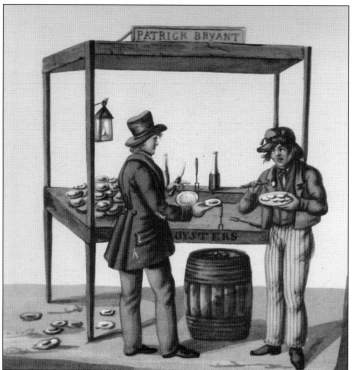

Street vendors offered 12-inch oysters for sale. An early oyster store on Stuyvesant Street doubled as a post office. Oysters were plentiful in the Hudson River and Long Island Sound.

This is the Oasis of Washington Square, with owner Grace Godwin at the window in 1917. The garret's previous owner, Guido Bruno, often hired actors to be "bohemians" to impress tourists. Originally, this house on Washington Square South was home to Daniel Megie, the hangman of Washington Square. (Photograph by Jessie Tarbox Beals, courtesy New-York Historical Society.)

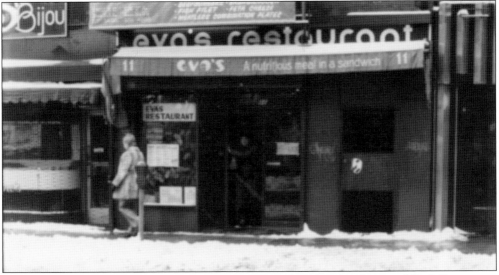

On Eighth Street, many business enterprises come and go, but family-owned Eva's Restaurant at 11 West Eighth Street has maintained its enduring tradition of serving Mediterranean-style health food since 1978. Now considered a landmark, it has become a regular stop for many New Yorkers, including professional athletes, musicians, artists, and others interested in good health. (Courtesy Eva's Restaurant.)

The Pepper Pot of Greenwich Village is pictured. In the mid-1920s, the Pepper Pot, located at 145–150 West Fourth Street, was a hot nightspot. It was near the Dragon Inn on West Third Street, across from Mother Bertolotti's, the Village Mill (where Eddie Condon played), and the Black Cat.

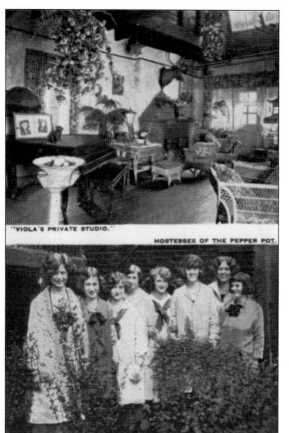

"VIOLA'S PRIVATE STUDIO."

HOSTESSES OF THE PEPPER POT.

A speakeasy (a place that served liquor during Prohibition) business card from 1929 shows the dining room at 239 West Fourth Street (more recently Fedora Restaurant). On the reverse side, only the first name, a phone number, and an incorrect address are given. Prospective customers called the number and got the necessary information if they passed scrutiny. By day, Charlie Dorato worked in his cousin's shop at the Gansevoort Meat Market. At night, he operated his own business, the speakeasy known then as Charlie's Garden. Fedora Restaurant recently closed its doors. (Courtesy Marilyn Dorato.)

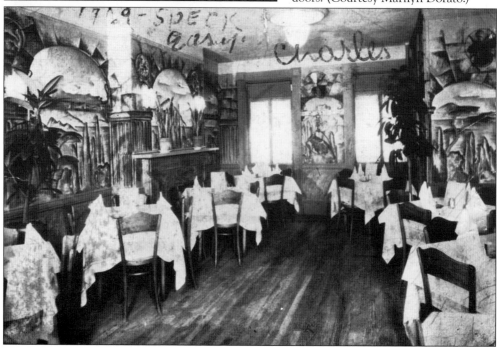

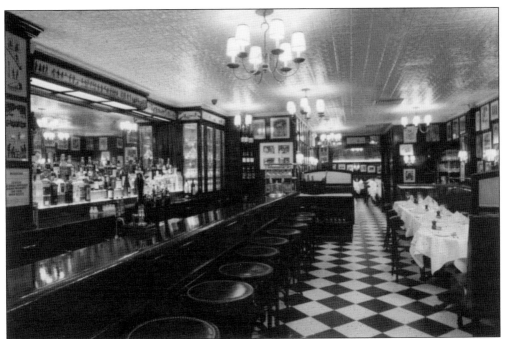

Minetta Tavern has been the culinary destination of the rich and famous since 1937. The map on the wall recalls famous city landmarks, including Jimmy Kelly's (with exotic dancers), the Rhinelander Mansion (left of Fifth Avenue), the Jumble shop, and MacDougal Alley. (Courtesy Minetta Tavern.)

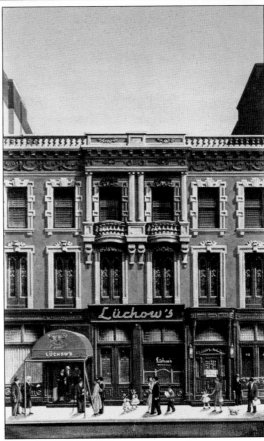

Since 1882, Luchow's Famous Restaurant at 110–112 East Fourteenth Street has been a favorite eating place of the world's celebrities. Earlier, Fourteenth Street was the hub of the theater district and silent-screen industry. Upon entering the restaurant, one was guaranteed superb food, imported beers, and fine wines, as well as a lively band and costumes for souvenir picture-taking. (Courtesy Luchow's.)

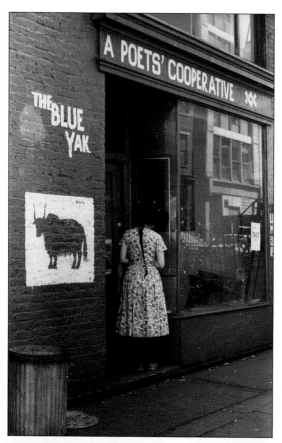

During the 1950s, the Blue Yak, a poets' cooperative, attracted many curious people. Many poets gathered in coffeehouses and cellars to read their own works and to find kindred beatnik spirits. (Photograph by Jan Yoors.)

Le Figaro Cafe, the San Remo Café, Café Wha?, and Judson Memorial Church all held poetry readings by the Beats, including Jack Kerouac and Allen Ginsberg. (Photograph by Jan Yoors.)

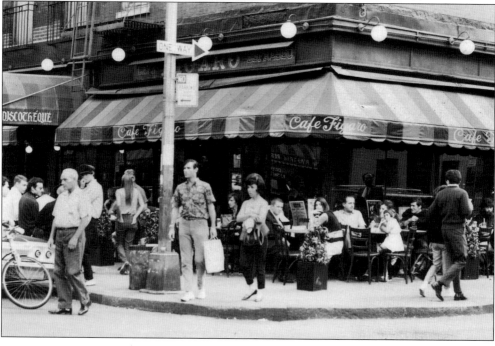

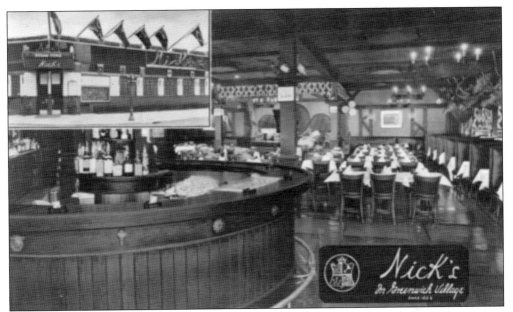

Nick's at Seventh Avenue and Tenth Street was a favorite locale where many jazz musicians jammed and performed in the 1940s and 1950s. It was located up the street from Café Society at 2 Sheridan Square.

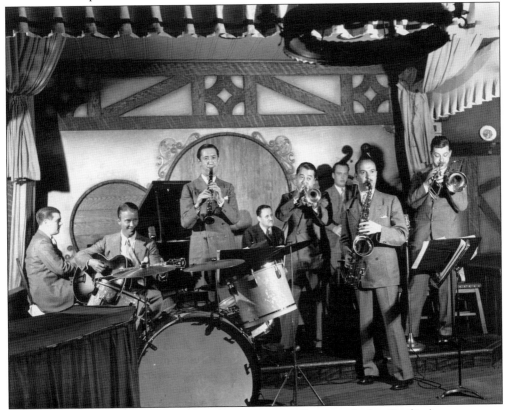

Nick's Summa Cum Orchestra is shown here. (Courtesy Institute for Jazz Studies.)

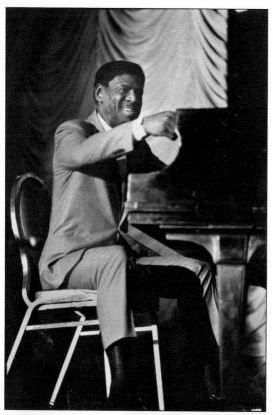

Earl "Fatha" Hines is pictured at the piano at the famous jazz venue the Village Vanguard. Adolph Green, Betty Comden, Leadbelly, Pete Seeger and the Weavers, Dinah Washington, and Miles Davis all performed here. Max Gordon started the club in 1935. (Courtesy Institute for Jazz Studies.)

Billie Holiday sings at Café Society, where she introduced "Strange Fruit." Lena Horne decided to give up dancing and become a singer at Café Society. Imogene Coca, Josh White, and Mary Lou Williams played here. It was opened by Barney Josephson in 1938 and catered to an unsegregated audience. In 1970, Josephson's brother opened the Cookery, where Alberta Hunter entertained crowds, on Eighth Street and University Place. (Courtesy Institute for Jazz Studies.)

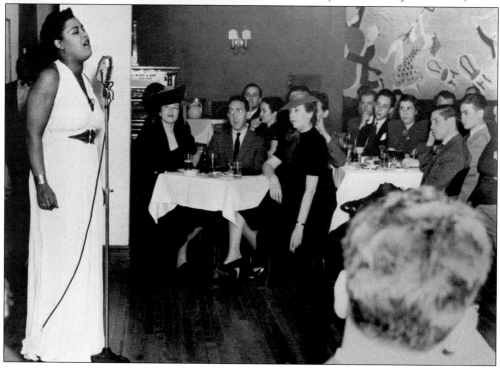

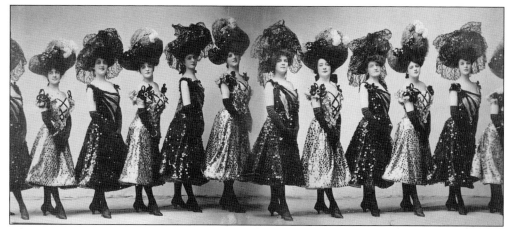

Although this particular chorus line is unidentified, the theater district on Fourteenth Street and Broadway featured showgirls like these in the 1910s. Evelyn Nesbit, the teenage model and protégée of architect Stanford White, was a showgirl on Broadway 10 years earlier, before she married millionaire Harry Thaw, who killed White at White's nightclub atop Madison Square Garden in 1906.

This is Greenwich Village Follies sheet music from 1922. The Greenwich Village Follies productions became so popular that they often moved productions uptown.

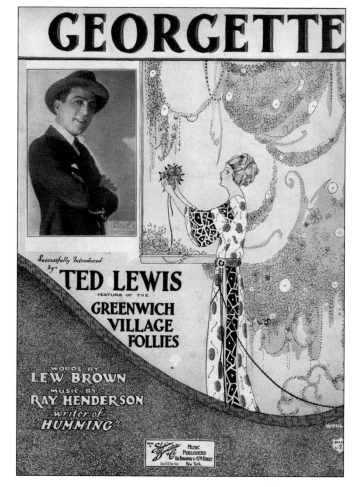

> "Prophet!" said I, "thing of evil!—
> Prophet still, if bird or devil!—
> Whether Tempter sent, or whether
> Tempest tossed thee here ashore,
> Desolate, yet all undaunted,
> On this desert land enchanted—
> On this home by Horror haunted—
> Tell me truly, I implore—
> Is there,—*is* there balm in Gilead?—
> Tell me—tell me, I implore!"
> Quoth the Raven, "Nevermore."

Edgar Allan Poe lived in a house on Third Street, between Sullivan and Thompson Streets. New York University recently erected another building on the site but marked it with a plaque. (Courtesy Edgar Allen Poe Museum.)

Fourteenth Street Theatre at Sixth Avenue and Fourteenth Street was built in 1866. It had been part of the busy theatrical district on the street. This photograph was taken when the theater had changed over from live theater to showing films. In 1926, the celebrated actress Eva Le Gallienne opened Civic Repertory Theatre and produced plays by Ibsen, Chekov, and Shakespeare. The theater was demolished in 1938. (Photograph from brooklynpix.com)

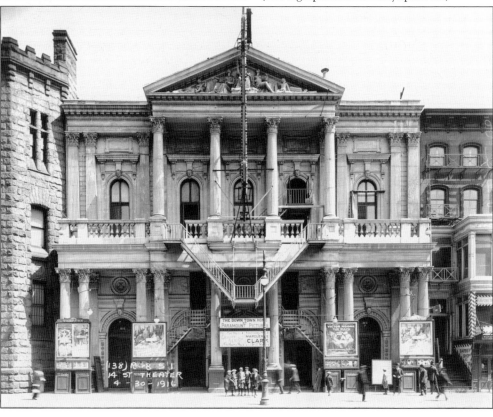

This is a cover from *The Masses*, a socialist magazine edited by Max Eastman. It first found its way into print in 1911. Its office was located at 91 Greenwich Avenue. The magazine had problems finding sales outlets due to its radical content. Attacks on the magazine increased the size of audiences at Max Eastman's lectures.

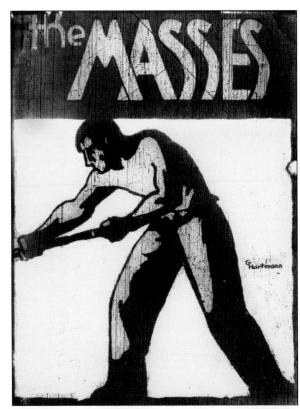

The Leveroni family earned 4¢ per gross making violets at 122 Sullivan Street. They could make 20 gross a day when the children worked all day. Their father had work elsewhere. Pictured are Mrs. Leveroni and her children. These children worked on Saturdays, afternoons after 3:00, and evenings until 8:00 or 9:00. (Courtesy Library of Congress.)

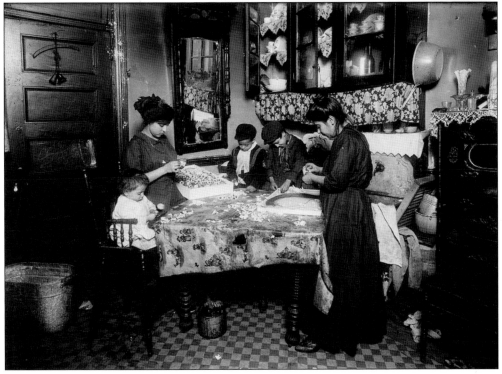

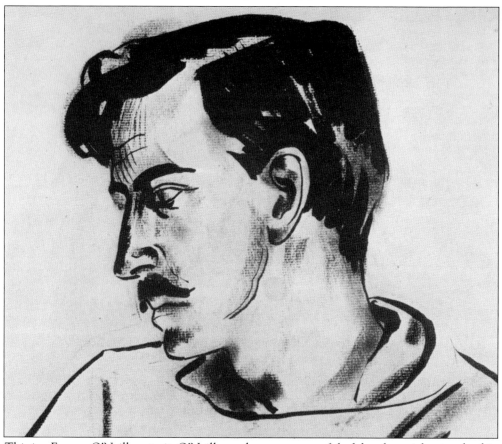

This is a Eugene O'Neill portrait. O'Neill was the most successful of the playwrights involved in the Provincetown Playhouse, located at 137 MacDougal Street.

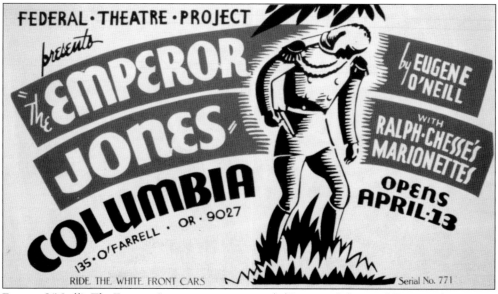

Eugene O'Neill's *The Emperor Jones* poster is pictured. (Courtesy Library of Congress.)

A Judson Poets Theater program from the 1960s is shown here. Under pastor and Village Independent Democrats president Howard Moody, Al Carmines produced the most innovative musical productions, and Remy Charlip choreographed. Carmines was a pioneer in off-Broadway productions. When it was built in 1890, Judson Memorial Church sought to bring together the socialites on the north side of Washington Square with the immigrants living on the south side of the park.

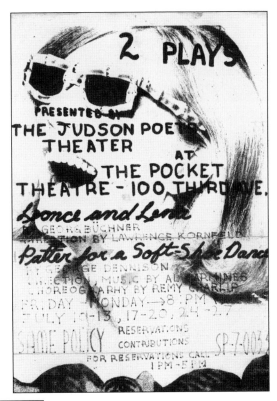

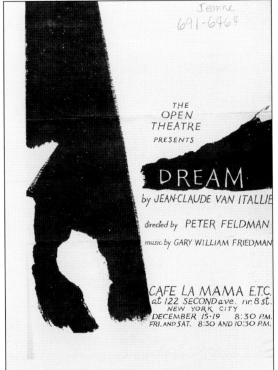

Dream, by Jean-Claude van Itallie, was presented at Café La Mama E.T.C. (experimental theater club). Ellen Stewart founded Cafe La Mama on East Fourth Street. It was a place where aspiring and honored playwrights presented their productions off Broadway.

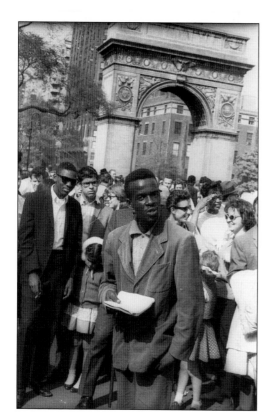

An unidentified poet reads from his work in Washington Square Park. The landmark marble arch stands 77 feet high at the south end of Fifth Avenue. (Photograph by Jan Yoors.)

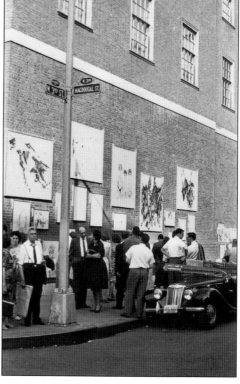

An artist with a ladder atop his sports car is pictured at the semiannual Washington Square Art Show, which started in 1932. The ladder helped him hang his art higher on the wall, making it more visible to potential clients. An artist could be more creative at the show then than today, when each artist is consigned a small booth. (Photograph by Jan Yoors.)

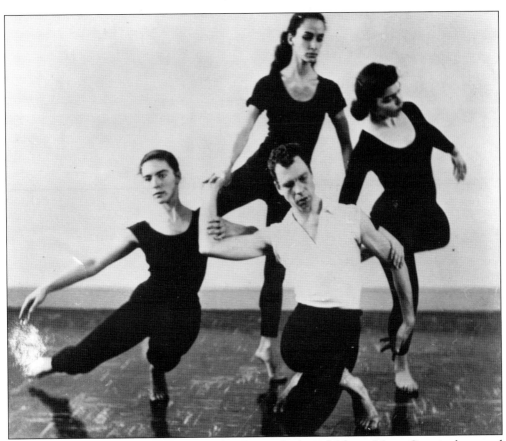

Pictured are, clockwise from the top, Carolyn Brown, Jo-Anne Melsner, Merce Cunningham, and Marianna Preger Simon in *Septet* (1953). The Cunningham Dance Studio was at the northeast corner of Fourteenth Street and Sixth Avenue. (Courtesy Merce Cunningham Foundation.)

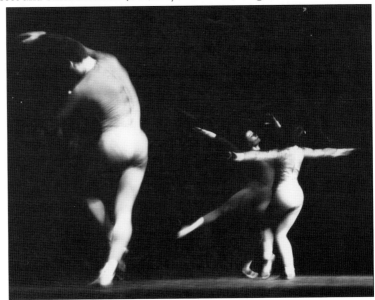

The dance group Motion, with Hellmut and Ingeborg Fricke-Gottschild and Renate (surname unknown), performs at Judson Memorial Church in the 1960s. (Courtesy Juergen Sandbothe.)

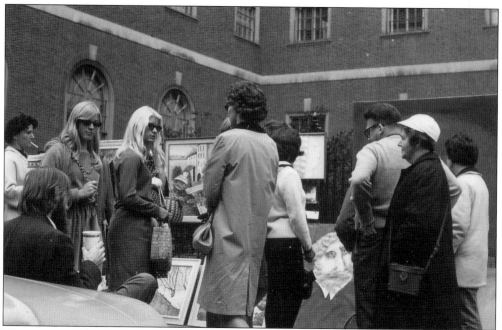

The semiannual Washington Square Art Show attracts blondes and other various shoppers. (Photograph by Jan Yoors.)

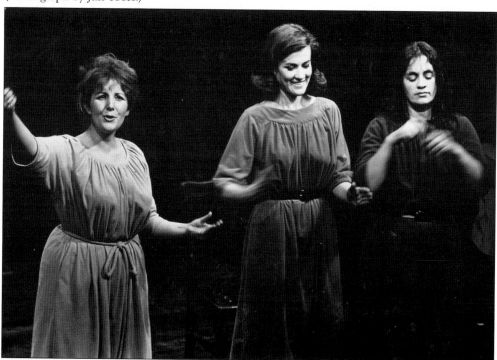

Sharon Gans, Cynthia Harris, and Isabelle Blau appear in *Calm Down Mother: A Transformation* by Megan Terry, an Open Theatre production, in 1965 at the Sheridan Square Playhouse. Jerome Ragni and James Rado, who coauthored the musical *Hair*, Sam Shepard, Joe Chaikin, and Jean-Claude van Itallie were part of the Open Theater. (Courtesy Phill Niblock.)

Earlier in the 20th century, No. 61, the "House of Genius" on the south side of Washington Square, became famous because so many talented artists and writers rented rooms from Madame Marie Branchard.

The Mark Twain House at 21 Fifth Avenue attracted tourists seeking celebrity sites when Mark Twain's writing was popular. Celebrity sightings continue. (Courtesy Greenwich Village Society for Historic Preservation.)

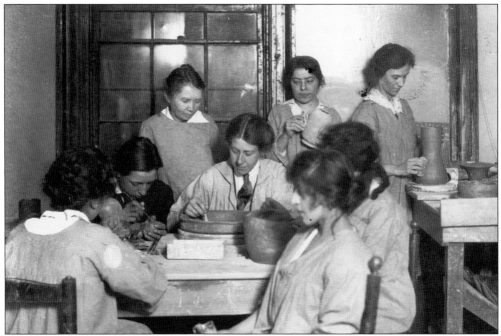

Greenwich House pottery classes were held for older youngsters. The school has been in existence for over 90 years. (Courtesy Greenwich House Pottery.)

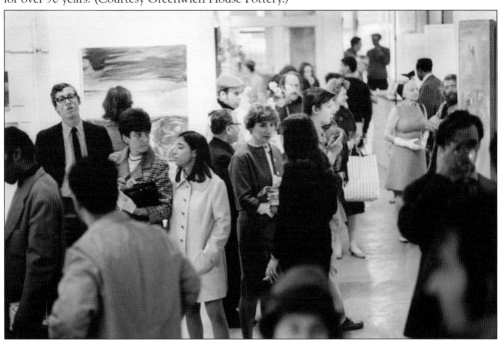

This is the opening of the Terrain Gallery, located at 39 Grove Street. Established in 1955, the Terrain published Eli Siegel's work and held exhibitions, dramatic events, and art talks presenting the new relation of art and life. In 1973, it expanded, becoming the not-for-profit Aesthetic Realism Foundation at 141 Greene Street, where the gallery continues to have exhibitions. (Photograph by Louis Dienes.)

Six

CELEBRATIONS AND STREET SCENES

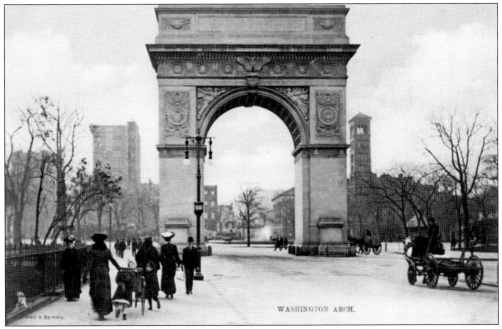

This charming postcard shows the Washington Arch at the turn of the 20th century. It was completed in 1892. Judson Memorial Church can be seen to the right of the arch. Both structures were designed by architect Stanford White.

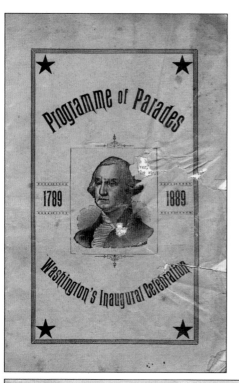

This is the *Programme of Parades* for April 29, 1889, featuring a Naval parade, the ball, and the banquet. On Tuesday, April 30, there was a military parade, and on Wednesday, May 1, there was an industrial parade that ended with fireworks and a concert. Washington Square Arch was lit with hundreds of newly mass-marketed incandescent lightbulbs and festooned with papier-mache wreaths and garlands

This is a description of the three triumphal arches (see page 2).

Triumphal Arches.

In order to give further brilliancy to the great occasion there are three triumphal arches erected, under which those who take part in the military and civic parades will pass. The arches will be located as follows :

At Fifth avenue and Twenty-third street.
At Fifth avenue and Twenty-sixth street.
On Fifth avenue at Washington square.

The grand arch at Twenty-third street is a single span, 100 feet wide and 77 feet high in the center, 46 feet in the clear from pavement to middle of the under side of the arch. The pillars are 12 feet wide and 8 feet in depth. It represents a gateway of brown stone 8 feet in thickness surmounted by two enormous golden eagles 24 feet high, one on each side. The walls are pierced to resemble battlements, and there is a tower at either side, each with four turrets 22 feet higher than the tops of the towers from which the arch springs. There are medallions of Washington and other Revolutionary heroes, life-size statues of a Continental soldier and a sailor in niches, portraits and busts of Washington's generals and paintings representing scenes in the Revolution. The American flag surmounts the battlemented pediment and the red, white and blue drape the sides of the arch.

The arch at Twenty-sixth street is of a similar character both in general style and effect, but with a triple span—one over the roadway and two over the sidewalks.

The arch at Washington square is a single span of forty feet, sixty-two feet high and forty-three feet in the clear. It represents stone and is decorated with eagles, bunting, wreaths and flowers. The spandrels are covered with laurel leaves and wreaths.

This newspaper article describes the events for April 29 through May 1: "The Inauguration Centennial Banquet, at the Metropolitan Opera House at night, was the crowning glory of the celebration of Tuesday. . . . It was worthy of the patriotic sentiment that perpetuates the memory of men of deeds and makes their names immortal." On the other hand, police had their hands full controlling the lively crowds on hand to watch the festivities on the street. President Benjamin Harrison, New York governor David B. Hill, former presidents Rutherford B. Hayes and Grover Cleveland, General Sherman, and many other dignitaries attended.

Here is another view of the *Programme of Parades*, noting places of interest, including the Battery, Trinity Church, the Custom House, New York Post Office, buildings housing the city's newspapers, and Washington Square, City Hall, Tompkins Square, and Bryant Parks. At the Brooklyn Bridge, a cable-pulled car ride cost 3¢, and a promenade could be made along the span for 1¢.

THE WASHINGTON CENTENARY.

A BRILLIANT BANQUET.

TOASTS TO WASHINGTON, THE STATES AND THE FEDERAL GOVERNMENT.

LIVELY TIMES IN WASHINGTON SQUARE.

EARLY THRONGS AT THE STAND—COLLISIONS BETWEEN THE CROWDS AND THE POLICE.

Some of the Principal Places and Buildings of Interest in New York City and Surroundings. Where Situated, and how to get there.

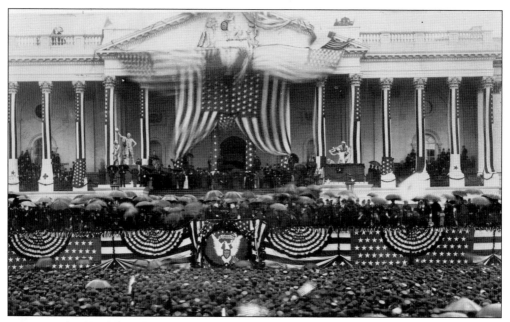

Pres. Benjamin
Harrison's presidential
inauguration is pictured
in Washington, DC, in
March 1889. (Courtesy
Library of Congress.)

Benjamin Harrison
was the 23rd president
of the United States.
He attended the
centennial celebration
of Washington's
inauguration in New
York City in April
1889. (Courtesy Library
of Congress.)

In 1976, New York celebrated the nation's bicentennial. This included a fleet of tall ships on the Hudson River called Operation Sail. The 30-mile armada of 53 ships from more than 50 countries plus hundreds of private vessels sailed from the Canary Islands and arrived in New York on July 3, 1976. This view from artists' housing at the Westbeth includes the elevated West Side Highway, the barges, and an undeveloped New Jersey shoreline.

This 1976 view includes the crowd at Westbeth on the roof to view the parade of ships.

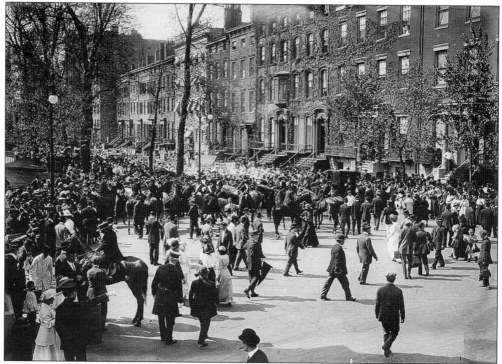

In this image, a group assembles for a suffrage parade in Washington Square on May 3, 1913. (Courtesy Library of Congress.)

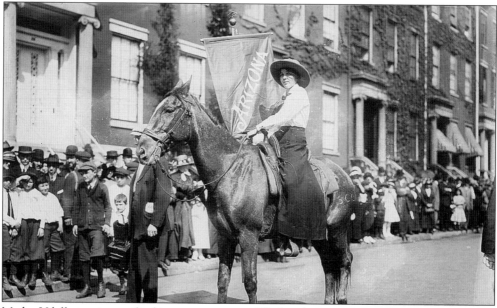

Madge Udall, wearing a split skirt on a western saddle (revolutionary in itself, as it was customary at the time for women to ride sidesaddle wearing a conventional skirt) makes a stand on horseback. The photograph was distributed by the Bain News Service located on Fourteenth Street. It was one of the first news services to distribute news photographs to other newspaper. (Courtesy Library of Congress.)

Women picket tailors after the tragic Triangle Waist Company fire in 1911 at 23–29 Washington Place. The doors were locked to keep the seamstresses from leaving early or stealing fabric. (Courtesy International Ladies' Garment Workers' Union Archives, Cornell University.)

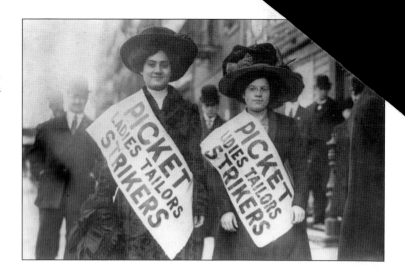

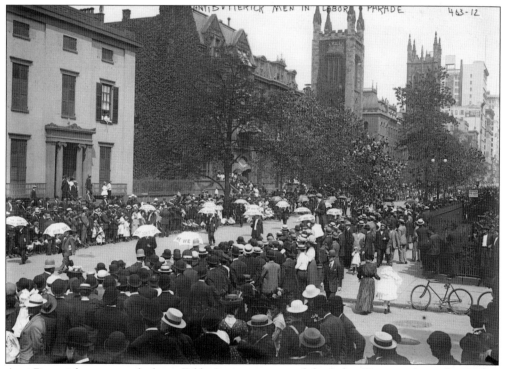

Anti-Butterick men march down Fifth Avenue as part of the Labor Day parade on September 9, 1908. The spires of Church of the Ascension on Tenth Street and the First Presbyterian Church on Twelfth Street can be seen in the background. The Butterick Building at Spring and MacDougal Streets was built in 1903. At that time, Butterick Pattern Company was one of the largest manufacturers in the world and had the largest publishing plant in the United States, with the exception of the government printing office. At 16 stories, it was the tallest structure in the area.

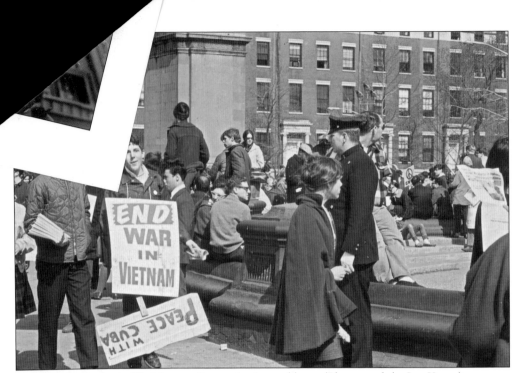

A Vietnam protest in Washington Square is pictured here. (Photograph by Jan Yoors.)

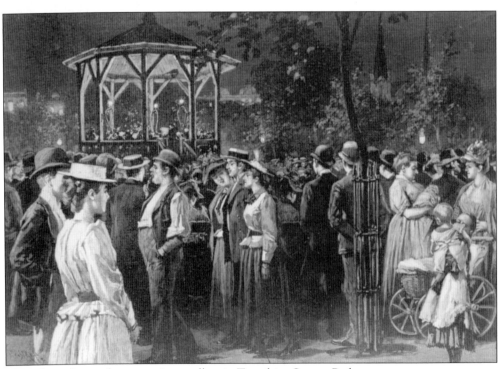

Music from the gazebo entertains strollers in Tompkins Square Park.

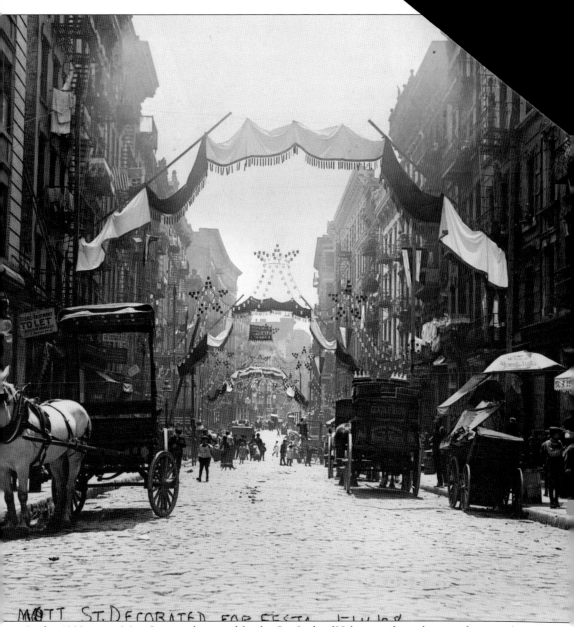

In this 1908 image, Mott Street is decorated for the Our Lady of Help street festival in a predominantly Italian neighborhood near Broome Street. This view includes the wagon of Gentile Brothers, Manufacturers of Mineral Waters. Fire escapes are adorned with drying laundry, and children stroll unattended along the cobblestones and sidewalks. An American flag and the old national flag of Italy which includes the House of Savoy symbol hang side by side (upper left). (Bain News Service photograph, courtesy of Library of Congress.)

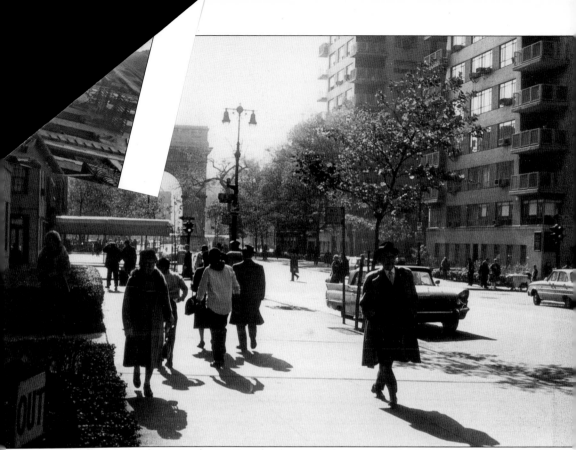

Fifth Avenue is shown in the 1960s. The first asphalt pavement in New York was installed in the 1880s on the lower few blocks of Fifth Avenue. Directly across the street is 10 Fifth Avenue, an 1848 townhouse where Guido Bruno had his Thimble Theatre, which opened in July 1915. Charles Edison, son of the inventor of the phonograph, set up shop on the ground floor selling phonograph records with little success. Bruno and Edison set up a hand-cranked phonograph in Washington Square. Strollers were surprised to hear music coming out of the bushes with no musicians to be seen. They then moved the phonograph to the Holley Statue. Soon people came to hear concerts on the phonograph at 10 Fifth Avenue. (Photograph by Jan Yoors.)

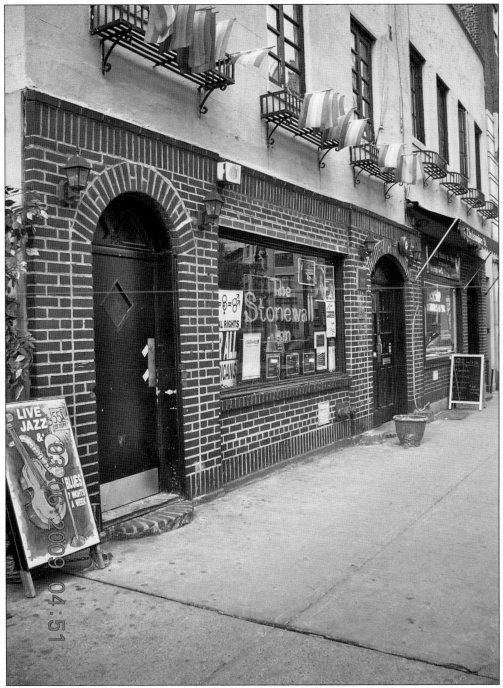

The Stonewall Inn on Christopher Street is pictured here. A police raid on June 28, 1969, touched off a riot that led to the start of a radical movement for gay liberation in the United States.

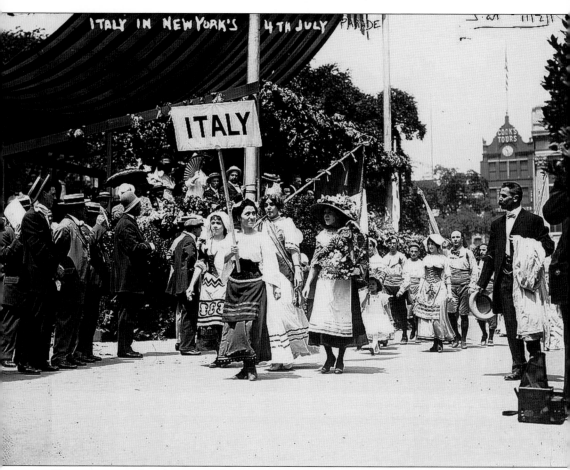

Showing national pride, many ethnic groups marched in parades, such as this group of Italians marching in the New York City Fourth of July Parade in 1911. (Courtesy Library of Congress.)

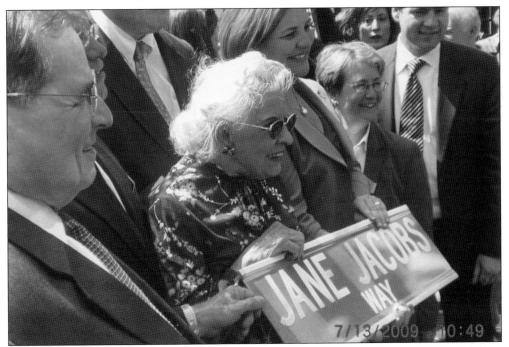

Doris Diether is the longest-serving member of any Manhattan community board. She is known as a font of zoning information and a fighter for neighborhood preservation. She helped Jane Jacobs thwart Robert Moses's urban renewal plan for the West Village. (Courtesy Doris Diether.)

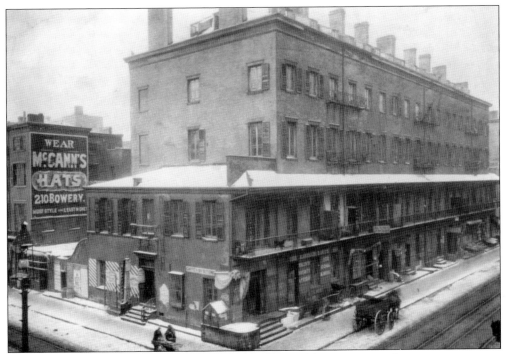

Pictured in 1896 is Bleecker Street, with a mix of businesses and apartments, near Thompson Street. (Courtesy New-York Historical Society.)

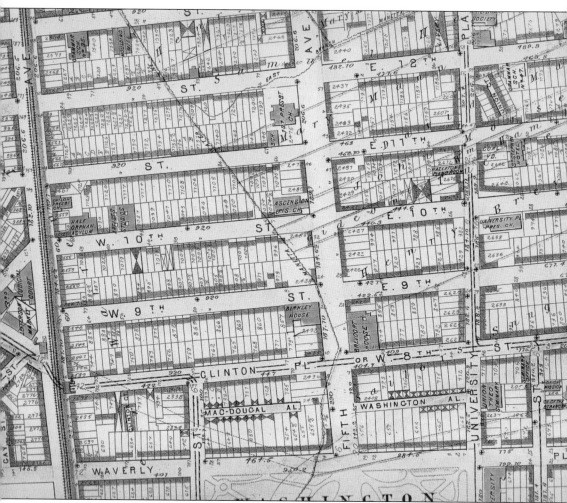

This 1879 map shows the north side of the neighborhood, Wards 9 and 15. Artists Studios and Half-Orphan Asylum can be seen marked on Tenth Street. The sites of the elevated train stations at Eighth Street near the Jefferson Market, Church of the Ascension at Tenth Street and Fifth Avenue, the First Presbyterian Church on Twelfth Street and Fifth Avenue, and Union Theological Seminary on University Place can also be seen.

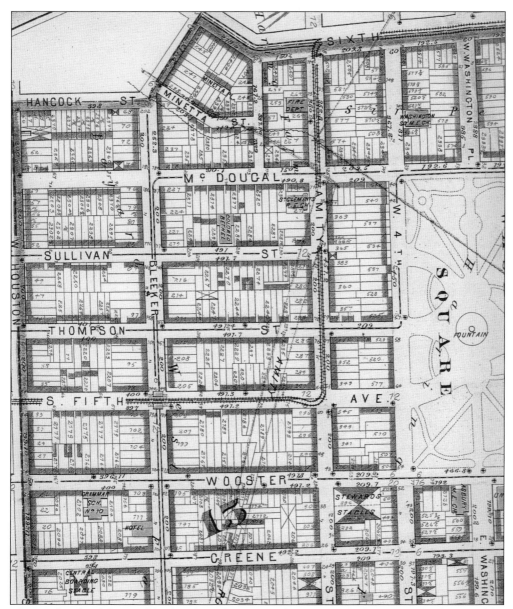

The south side of the neighborhood can be seen in this map. A firehouse on Third Street (aka Amity Street), Stewart Stables on Wooster Street, and "Colored Bethel" (Bethel AME Church) on Sullivan Street are indicated. The area known from roughly 1870 to 1920 as "Little Africa" was located in the southern and western portions of the village. Steam railroad lines and street railways are marked with dotted lines.

When John Tyler married Julia Gardiner at the Church of the Ascension on lower Fifth Avenue in 1844, he became the first president to marry in office. The bride's family, of Gardiners Island fame, lived in Collonade Row at the time. (Courtesy Greenwich Village Society for Historic Preservation.)

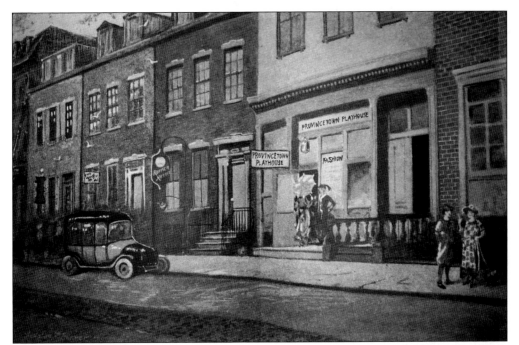

Edna St. Vincent Millay (partly named for St. Vincent's Hospital) was active in the Provincetown Playhouse, located at 139 MacDougal Street. Eugene O'Neill got his start here. (Courtesy *Valentine's Manual of Old New York*.)

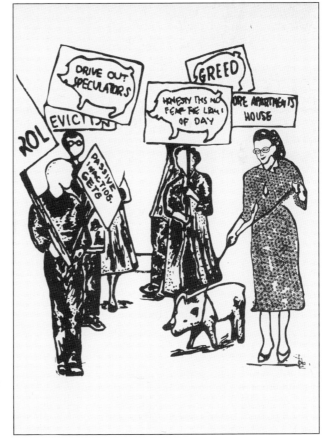

This is a drawing that ran in a New York City newspaper on May 22, 1960, with the headline "Pig Pickets to Save Village". The caption reads, "Mrs. Doris Diether leads pig on leash. She heads a group of sign-carrying Greenwich Villagers protesting outside Gov. Rockefeller's office at 22 W. 54th St. Using the rented pig as a symbol of greed and avarice, the Save the Village Committee is seeking to halt demolition of older buildings to make way for luxury apartments." (Drawing by Tatiana Toro, based on original appearing in newspaper at the time.)